Printed

Th¹
I⁺

PRINTED ART
A VIEW OF TWO DECADES

RIVA CASTLEMAN

THE MUSEUM OF MODERN ART NEW YORK

Designed by Nora Sheehan
Typeset by Expertype, Inc., New York, N.Y.
Color separations by L S Graphic Inc., New York, N.Y.
Printed by Baronet Litho, Inc., Johnstown, N.Y.
Bound by Sendor Bindery, Inc., New York, N.Y.

The Museum of Modern Art
11 West 53 Street, New York, N.Y. 10019
Printed in the United States of America

CONTENTS

PREFACE

Since 1964, the year of the influential exhibition "Contemporary Painters and Sculptors as Printmakers," no full-scale survey of contemporary prints has been presented at The Museum of Modern Art. Over the past sixteen years, the most important artists of the period have devoted much of their creative energies to the print media, and it is appropriate that another exhibition document what has been called a renaissance of printmaking.

Lithography was revived in the early 1960s in America, while the mid-60s saw the intensive use of silkscreen throughout America and Europe. New technologies offered an increase in scale, so that prints approached the size of paintings. After some experimental work in etching in the late 1960s, artists found approaches to intaglio techniques that were quite different from those of the pervasively influential S. W. Hayter. The use of aquatint, in particular, has changed the look of prints. The recurrence of the earliest use of prints, as documents or as aids to an activity, is an important aspect of work produced in the 1970s. Photographically induced imagery (along with the techniques that the artist has had available to transform it into mechanically printed form) has been a dominant factor in this period, manifested in large-scale offset prints and intimate bookworks. More than just printed souvenirs of the major stylistic movements of the last decades, the prints of Pop, Op, Minimal, Conceptual, Photo-Realist, and recent figurative artists are of major significance in the understanding of the art of our time. Printed art produced by most contemporary artists is an integral part of their creative activity and represents a fundamental aspect of artistic endeavor during the past twenty years.

The formation of this exhibition has been facilitated by the advice and cooperation of many artists, artisans, entrepreneurs, curators, and art historians. Among them the following have been particularly liberal in sharing their knowledge: Brooke Alexander, Brooke Alexander, Inc., New York; Kees Broos, Curator of Prints, Gemeentemuseum, The Hague; Kathan Brown, Crown Point Press, Oakland, California; Aldo and Piero Crommelynck, Paris; Michael Domberger, Domberger KG, Stuttgart; Richard S. Field, Curator of Prints, Yale Art Gallery, New Haven; Sidney Felsen, Gemini G.E.L., Los Angeles; Susan Lorence Gadd, Petersburg Press, New York; Pat Gilmour, London; Marian Goodman, Multiples Inc., New York; Tatyana Grosman, Universal Limited Art Editions, West Islip, Long Island, New York; Colta Ives, Curator in Charge, Department of Prints and Photographs, Metropolitan Museum of Art, New York; Hiroshi Kawanishi,

Simca Print Artists, New York; Prawat Laucheron, New York; William S. Lieberman, Curator of Twentieth-Century Art, Metropolitan Museum of Art, New York; Rosemary Miles, Research Assistant, Prints, Drawings, and Photographs, Victoria and Albert Museum, London; Kynaston McShine, Curator of Painting and Sculpture, The Museum of Modern Art; Dr. Gunther Thiem, Chief Curator, Graphische Sammlung, Staatsgalerie, Stuttgart; Ken Tyler, Tyler Graphics, Ltd., Bedford Village, New York; Françoise Woimant, Conservateur, Cabinet des Estampes, Bibliothèque Nationale, Paris.

The private collectors and institutions that have lent works to the exhibition have been exceptionally generous. Our sincerest thanks are extended to William R. Acquavella, New York; Armand P. Arman, New York; Richard Brown Baker, New York; Sara F. Katz Howell, New Jersey; Mr. and Mrs. Harry Kahn, New York; Betsy Mize, Chelsea, Vermont; The Collection of Mr. and Mrs. Burton Tremaine, Meriden, Connecticut; Stedelijk Museum, Amsterdam; The Trustees of The Tate Gallery, London; Victoria and Albert Museum, London; Metropolitan Museum of Art, New York; Bibliothèque Nationale, Paris; Staatsgalerie Stuttgart, Graphische Sammlung; Galerie Heiner Friedrich, Munich; Verlag Schellmann & Klüser, Munich; Barbara Gladstone Gallery, New York; Bernard Jacobson, Ltd., New York; Sidney Janis Gallery Editions, New York; Joan Kaplan, New York; Galerie Maeght, New York Office; Parasol Press, Ltd., New York; Petersburg Press, New York; Reiss-Cohen, Inc., New York; Sergio Tosi, New York; Galerie Stähli, Zurich.

I am most grateful to the members of the staff of the Museum who have assisted in the preparation of the exhibition and of this catalog; special thanks are due to Audrey Isselbacher, Curatorial Assistant, and Deborah Wye, Assistant Curator, both of the Department of Prints and Illustrated Books; Francis Kloeppel, Senior Editor; John Limpert, Jr., Director of Development; and Nora Sheehan, who has thoughtfully designed this catalog.

This exhibition was conceived with the encouragement of many persons, but particularly the members of the Committee on Prints and Illustrated Books and its Chairman, Mrs. Alfred R. Stern. The selection of works was facilitated by the assistance of The International Council of The Museum of Modern Art. However, without the imaginative and generous support of the McGraw-Hill Foundation, Inc., "Printed Art" could not have become a reality. I am pleased to extend the Museum's warmest appreciation to the Foundation for making "Printed Art" its first major effort in the sponsorship of exhibitions. R. C.

After World War II, European and American painters and sculptors discovered that making prints was an artistically justified, often remunerative, and gratifying outlet for their creative energy. Lithography and woodcut were the preferred media: the former, superficially requiring little technical knowledge or dexterity, for its similarity to drawing; the latter, reflecting the broadening interest in the newly rediscovered prints of the German Expressionists, for its direct and primitive technique. Eager to return to printmaking, in which they had enjoyed productive years during the late twenties and thirties, Picasso and Chagall led the way to the lithography workshops. Much-younger painters who had developed after the impact of Surrealism were also drawn to lithography and occasionally to the complex intaglio processes as means of disseminating their images.

In Europe there were still master lithographers with sufficient supplies of stones and printing machinery. They were able to help painters obtain their images by the traditional means of doing everything—from purely mechanical procedures to actually drawing the composition itself. In America offset printing had largely replaced hand lithography and few expert printers of the latter survived. The revival of hand lithography in the late 1950s made the medium available to many artists who provided the vital imagery that started the print boom of the past two decades. The extremely potent influence of S. W. Hayter and the Surrealist artists associated with his intaglio workshop, Atelier 17, both in Europe and America, slowly waned as news photography and commercial graphics superseded the subconscious as sources of subject matter. Because the expanding dimensions of prints required larger presses and bigger sheets of paper, neither of which had been developed by 1960, lithography, a growing industrial medium, was more adaptable to the new imagery than intaglio. The huge woodcuts of Leonard Baskin of the 1950s that forecast this expansion to wall-oriented prints were made from readily available planks of commercial plywood and were printed on large sheets of shoji-screen paper, newly discovered by Westerners during the postwar occupation of Japan.

If the fifties were a period of discovery, the sixties were one of explosive development. By the early sixties Pop art, the controversial style with subjects too familiar and banal to be taken seriously, had a large enough

audience to encourage its most important practitioners to make prints. The introduction of printed passages in paintings (Rauschenberg, *Crocus*, 1962) and the appropriation of commercial graphic material in paintings (Lichtenstein's use of Benday dots in 1961) were eclipsed by Andy Warhol's singular use of silkscreen for all his work: canvases, sculptures, and editioned prints. In Europe Martial Raysse, Alain Jacquet, and Sigmar Polke, among others, took the same means to achieve their canvases for a few years.

While artists had utilized printed material for their collages fifty years earlier, the substitution of printing (the medium of multiplication) for painting (long accepted as a medium of unique works) has considerably broader implications. When an artist uses printing technology for an image that has developed out of a private expression, a revival of an older creative relationship begins. Centuries ago, when an artist delegated the less important details of a painting to helpers or authorized others to make fine engravings of his images, carrying them to the wide world, he was closely integrated into the general functioning of working society. When the personal sensitivity of an artist became an essential attribute of his work and when the term "originality" referred as much to the artist's touch as to the emergence of a new image or concept, painters and sculptors fell out of "sync" with society. Understandably, their demonstration of independence from the social machine occurred most naturally in reaction to the Industrial Revolution. Thereafter, dependent apprentices were replaced by independent students, and prints done with varying degrees of changes were marked, numbered, and signed to show that the artist was truly involved in every stage. This conscious assertion of individuality, of handmade over machine-made, was never without its hypocritical side, since nearly every important print of the late nineteenth century was pulled by a master printer and his helpers. What was different was that the printer, whose name had often appeared on the finished product, now became anonymous. It became necessary to keep the lithographer's role, as well as technical improvement in the printing process, a guarded secret. There were, of course, brief but important periods of honestly handmade work, as during the Expressionist movement in Germany.

The Bauhaus envisioned a collaboration between the industrial complex and the artist, trying to integrate the artist into a society totally dependent upon machinery, though still wary of it. Geometric forms, exactly and infinitely repeatable, became the subjects of the art resulting from this

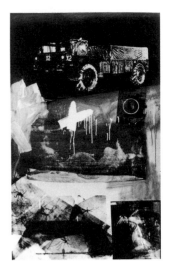

ROBERT RAUSCHENBERG. *Crocus.* 1962. Oil with silkscreen on canvas, 60 x 36" (152.4 x 91.5 cm). Collection Mr. and Mrs. Leo Castelli, New York.

confrontation. Josef Albers, first a student and later a teacher at the Bauhaus, had considerable influence in this area in the 1960s. When making prints, from the 1930s until his death in 1976, he utilized the tools of industrial draftsmen and worked with his printers toward a uniform and economical product. Between 1961 and his death at the age of eighty-eight Albers designed nearly three hundred prints, mostly silkscreens made from measured mechanical drawings with specific color instructions. Although he maintained this attitude of efficient collaboration in the mechanical manufacturing of prints, he continued to hand-paint his masonite-supported *Homage to the Square* series.

Meanwhile, having started his career as a commercial artist, Andy Warhol recognized the advantages of the collaborative system. Once he had evolved his subject, the secondhand, popular printed imagery of the supermarket and tabloid press, it took little time for him to determine that his art demanded printing. Most of his images were repeated, either within one canvas, or on a set of identical canvases, or on a set of boxes. Warhol set up his Factory to carry out the replication. Explaining how Warhol produced his "paintings," John Coplans wrote: "Since a major part of the decisions in the silkscreen process are made outside the painting [sic] itself (even the screens for color can be mechanically prepared in advance) making the painting is then a question of screening the image or varying the color. These decisions can be communicated to an assistant... what obviously interests Warhol is the decisions, not the acts of making."[1] This attitude toward the creation of art is perhaps the most fundamental characteristic that differentiates art of the 1960s and 70s from most of the art of the twentieth century.

A prejudice against silkscreen existed, even into the 1960s. As late as 1965 the silkscreens of the British painter Patrick Caulfield were relegated to "no-man's-land" in the Paris Biennale solely on the basis of their technique, even though they won the prize for graphics. Silkscreen shared with the classic printing media very few of their production methods, and this dearth of clues to the process of manufacture led to widespread distrust of the "originality" of the art itself. The technique of printing through a stencil supported by a web of finely woven silk was commercially developed in America at the beginning of the century. First used to print produce labels, silkscreen was discovered to have the potential of reproducing many of the

1. John Coplans, *Andy Warhol* (Greenwich, Conn.: New York Graphic Society, 1970), pp. 50–51.

properties of painting. The artists who pioneered the use of silkscreen in the 1930s, and who differentiated their work from the commercial techniques by naming it "serigraphy," tended to exploit its painterly qualities. A few recognized that silkscreen also possessed the capability of printing flat, consistent passages of color with sharply defined edges. Perhaps the most important characteristic of silkscreen for the artists of the postwar period was its economy. A few pieces of wood, silk (later replaced by polyester), material to create the stencil forms, a squeegee, and paint were the basic elements. Photographically produced stencils could be ordered from the commercial printer.

In the 1950s silkscreen experts began to produce excellent reproductions of paintings. Arcay, the Havana-born commercial screenprinter, interpreted the works of the artists associated with the Parisian abstract movement around the publication *Art d'Aujourd'hui*. Since many of the artists, for example, Mortensen and Vasarely, supervised the realization of their work in silkscreen and advocated the proliferation of their images by this means, it was a logical step to accept their silkscreened images as part of their original oeuvre. Most important, however, to the development of silkscreen was the fact that it lent itself especially to art that exploited clear colors and simple shapes.

When Luitpold Domberger saw an exhibition of serigraphs at one of the Amerika Haus galleries run by the United States Information Service in Germany shortly after World War II, he immediately recognized the potential of silkscreen. In 1950, offering the medium to his friend, the painter Willi Baumeister, whose flat color-forms were easily and clearly executed with the screens, Domberger developed a rather primitive and certainly unsophisticated technique into a refined, highly mechanized, and exact industry. Many of the artists whose work was categorized as Optical art became widely known through the silkscreened prints made at Domberger's shop in Stuttgart. Albers, Vasarely (formerly a student of a Bauhaus alumna), Mortensen, Mavignier, Cruz-Diez, and Soto are only a few of the artists whose designs for silkscreens were cut into stencils and printed at Domberger's. Directly responsive to the increased numbers of persons who found pleasure in pure-color geometric forms and disliked or felt discomfort in the presence of Expressionist abstractions or Pop representations (the New Realism), publishers commissioned these artists to create prints of their work. In some cases the optic effects were easily obtained through the use of paints containing fluorescent colors; in others dozens of screens were needed for one print to capture subtle color

changes. In both instances silkscreen printing provided the ideal means for such ends.

The method of creating screens in the 1960s became progressively more mechanical. Hand-cutting of the stencils was carried out by an expert rather than the artist, so a maquette was often an essential beginning. In England Christopher Prater, a commercial screenprinter, worked closely with three artists, Eduardo Paolozzi, R. B. Kitaj, and Richard Hamilton, whose work may be used as examples in the development of silkscreen imagery. They all utilized collage, a technique perfectly suited for silkscreen. Eduardo Paolozzi had, during the 1950s — and perhaps influenced by Matisse — screened patterns and colors on sheets of paper which he subsequently cut out and used as elements in large collage-compositions. For his silkscreen prints of the 1960s Paolozzi similarly created screened elements from which he formed complex collaged maquettes. Because of the flexibility of screenprinting, each print in an edition could look different — thanks to changes in the order in which the screens were printed. Translucent and opaque inks and varnishes, often printed in layers, one screen after another, can produce a wide range of variation or invariable uniformity, depending upon the artist's desires. Paolozzi's amalgamations of found graphic objects (parallel to his sculpture utilizing found metal objects) formed several sequences of prints based upon philosophy, biography, and scientific study, which, as subjects for art, were unexpected. The use of visual material commercially produced for mass consumption emphasized the artist's particular attitude toward such subjects.

R. B. Kitaj, who left America for England in 1958, was less inventive in his exploration of silkscreen with Prater, although his collage style of work focused more specifically on the evolution of form and ideas. Nearly always literary in content, Kitaj's series *Mahler Becomes Politics, Beisbol*, 1965, and his later set of book covers *In Our Time*, 1969, juxtapose borrowed images, systems of compositions, quotations, and historically associated colors. His most complex prints are each, in effect, a group of witty conversations brought together in eye-splitting simultaneity.

Many artists, particularly the assemblers of *objets trouvés*, maintained an element of distance from social commentary, but others who consistently selected their materials for content, such as Richard Hamilton, often took up directly either advocacy or opposition. Hamilton's first collage-silkscreens were, like his collage-paintings, comprised of popular advertising images, carefully chosen and composed to reveal their

subliminal content. The materials and subjects of Hamilton's work, fundamentally "Pop" (as he himself termed it in his collage of 1956, *Just What Is It That Makes Today's Homes So Different, So Appealing?*) and by his own definition "expendable (easily forgotten)," nevertheless function ultimately as provocative criticisms of consumer society. Warhol's use of similar material (commercial labels, famous faces, news photos), even though many of his subjects are associated with death, defies such interpretations because of the abstracting effects of his repetitive imagery.

With its use in Pop art, silkscreen made an emphatic impression on the presentation of two-dimensional art in the sixties. Its continuous commercial use and its adaptability to photographic imagery made the silkscreen an incomparable tool in the creation of post-painterly art. Its use in conjunction with autographic imagery, however, was less successful except when, as in Warhol's later screens, it was closely associated with mechanically produced elements.

The revival of lithography in America that preceded the silkscreen revolution continued to influence the way art was printed for the entire decade of the sixties and longer. Major young talents like Rivers, Rauschenberg, Johns, Frankenthaler, and Rosenquist had been introduced to lithography by Tatyana Grosman at her Universal Limited Art Editions workshop outside New York City. A generation of American artists was exposed to the collaborative method involved in the creation of prints through the Tamarind Workshop in Los Angeles. The printers who received their training at Tamarind between 1960 and 1970 went on to found other workshops (Collectors, Hollander, Gemini, Cirrus, Landfall, etc.) and engage in the commissioning of printed art. The profusion of opportunities for artists to make lithographs accompanied the increasing public awareness of contemporary art, and provided the abundance of prints required to decorate the walls of people and companies wishing to project a modern image. Lithography became a big business that associated the most famous artists with an industry that they alone could sustain. A similar situation had prevailed a decade earlier in France when printers and publishers vied for the creative powers of those artists whose reputations were well established. In the cases of both France and the United States many excellent lithographs were produced, some that will undoubtedly last as masterpieces of our century. The lithography workshop, however, was the place where many artists became the equivalent of industrial directors of research and development. Those who created the best products inevitably could demand the best working and financial

arrangements. It was ever so when commerce stood between the creator and the consumer.

The well-funded printing company, to a large extent, affected the amount of time an artist would put into making prints rather than unique works. Jasper Johns and Robert Rauschenberg commuted between Universal Limited Art Editions (U.L.A.E.) and Gemini G.E.L. beginning in 1967. Claes Oldenburg and Roy Lichtenstein, who were introduced to Tamarind-style lithography at Irwin Hollander's New York shop, went on to Gemini in 1968 and 1969 respectively. Jim Dine moved to England in 1967, switching from lithography (U.L.A.E.) to silkscreen (Prater) and again to lithography (Petersburg). The English and American lithography shops quickly responded to the needs and demands of artists to use more than one printmaking medium. Wary of contamination at first, they handled silkscreening only through outside contracts; later, allegiance to one medium fell to the competitive sense of offering the most complete printing studio to the artist. Often interested in the same artists, Gemini and Petersburg were the most active competitors in this area during the seventies.

Intaglio (etching, engraving, aquatint, etc.) was, in the sixties, the medium least appealing to American painters. When, in 1967, Tatyana Grosman received a National Endowment grant from Washington to establish an intaglio workshop on her U.L.A.E. premises, most of the artists with whom she worked were totally ignorant of the techniques. Even so, intaglio was more of a conceptual than technical challenge to American artists. Most artists were inclined to work with color, while few color intaglio prints were available as examples of what could be achieved. The medium was replete with the mystique of alchemy, a feeling sustained by the influence of its chief magician, S. W. Hayter, that pervaded the university and art-school workshops.

In Europe, particularly in England, Italy, and France, etching was not so encumbered: Fontana could punch holes through his heavy intaglios, Soulages could let the acid burn off the edges of his plates, and Hockney could blithely scratch his anecdotal drawings onto plates unblessed by loops of the facile engraving that characterized so much of the work of Hayter's students. Picasso, having definitively settled in southern France, far from Mourlot's lithography workshop, devoted a large proportion of his time to making etchings—nearly 725 between 1957 and his death in 1973. Exhibitions of the 347 etchings he completed in 1968 focused awareness on the medium. It also became possible to print bigger plates in respectably large editions in the late sixties; Joan Miró created plates 41" x 29" in 1968

at Maeght's Arte workshop in Paris, and Valter Rossi made large etchings a speciality of his 2RC shop in Rome.

Etching and its associated techniques were used by the artists of the late 1960s and 1970s in several ways differing from the manners that were popular shortly after World War II. It was, of course, the artist's image that required changes of emphasis in the use of color, line, and tone. Photoetching, utilized by several Pop artists in their contributions to the six volumes of small intaglio prints titled *The International Avant-Garde* (1962-64), was used later by Johns and Hamilton to introduce photographic images into their work and, enhanced by the addition of aquatint scraping and further etching, by Paolozzi and Gerhard Richter.

Aquatint, used very neatly and uniformly, became the vehicle for brilliant, resonating color or fields of velvety white and black. The densely but lightly pitted surface of the aquatinted plate produced passages of rounded specks of ink that reflected light far more efficiently and vividly than either the flat ink of silkscreen or the infused surface of lithography. Robert Motherwell was one of the first to use this aspect of the medium in his work. It was difficult to achieve a perfect surface with aquatint, but Minimal artists, requiring that there be no blurring or suggestion of casualness, pushed expert intaglio printers like Kathan Brown and her Crown Point Press to develop a standard of precision that had not characterized the medium for decades. Sol LeWitt, who has made over 360 prints at Crown Point, required fastidiously treated plates for the myriads of straight and not-so-straight lines with which he filled his series of copper plates. These plates could not be successful if the slightest amount of ink remained on the surface to print between the sharp lines. Like some of the seventeenth-century Italian etchers whose crosshatching controlled their compositions, LeWitt sought clarity and precision in a medium that had so frequently been the vehicle for a looser, more casual execution.

While Ryman was completing his subtle, white Minimalist aquatints at Crown Point, Miró and Tàpies were working with resin and carborundum to create huge, often colorful prints with heavy relief passages. Anton Heyboer, Rolf Iseli, and Jim Dine dealt directly and defiantly with large sheets of roofing copper, preserving imperfections and incorporating them into their intense compositions. Picasso had produced the distinctive, small, mossy, lift-ground aquatints of the "347" etchings. The printers of the latter, Aldo and Piero Crommelynck, later extended their adventurous, though traditional, methods by working in photoetching and color aquatint with Johns and Dine.

Of the classic print media only the relief techniques have found few practitioners. Picasso's decorative and controversial linoleum cuts of the early 1960s seem to have had little influence upon artists except for their occasional shiny, bright colors, which could have been more easily achieved in varnished silkscreen. Old woodblock letters have been inserted, like found treasures, into lithographic compositions, but the directness with which artists now preferred to tackle the print media was hampered by the techniques of cutting as then perceived. One alternative was to take prefabricated pieces of wood, cut for construction purposes, arrange them into a composition, and ink them for printing. This technique has been used by two European sculptors, Carel Visser and Eduardo Chillida, whose three-dimensional work is similarly made up of preformed units. Helen Frankenthaler recognized in Edvard Munch's handling of wood two characteristics that she needed for her work: the translucency of ink printed from a large, flat-surfaced plank, and the sensitive linearity of sawed edges. These features she incorporated into her compositions at U.L.A.E. and at the workshop of Ken Tyler.

The work of Jasper Johns in the seventies sums up much of the fascination so many artists have had with the print media. His deft crosshatched compositions have been given a sparkling intimacy in color aquatint, a ghostly transparency in white lithography on black paper, an unexpected plasticity in gray and cream silkscreens, and an eye-taunting humor in one print that combines linoleum cut, woodcut, and lithography. Other artists, Hamilton and Dieter Roth, for instance, have had similar experiences in producing prints of identical subjects in several media. They took advantage of the superb technical skill that, by their new and unexpected demands, they had helped develop.

The changes in format of printed work during the past two decades have been as extreme as the changes in imagery. The size of prints in all media grew as the works, having replaced photomechanical reproductions of paintings on the walls of impecunious art lovers, began to assume the status of primary creative expressions and as such could no longer be condensed into much smaller scale. Where one image could not be printed on a large enough scale, series of identical or related images were made to be seen together in full wall installation. Warhol's *Flowers* and Ellsworth Kelly's first color lithographs were popularly exhibited this way. Rauschenberg's three-panel offset lithograph *Autobiography,* 1968, made on large machines designed to print billboard posters, measures 16-1/2' h. x 4' w. Sol LeWitt's prints are often meant to be displayed together in a

pattern regulated by the progress or transformation of the subject. Until paper and presses were developed in larger dimensions, artists had to put their work on more than one sheet if they wanted to achieve a large image that was both wide and high. Another alteration in format was due to experimentation with materials other than paper for support. Printing on cloth was done by several artists in the 1960s and has allowed prints to be handled and shown in the same manner as paintings. Plastic (PVC), becoming a popular material to print silkscreen upon, has provided both durability and larger scale.

The development of large sheets of paper was simultaneous with a growing concern for the material upon which images were printed. Throughout the century it was customary to use the French wove papers bearing the Arches trademark for lithography. Arches and Rives, both products of the Arjomari paper works, and the pearlescent papers of Japan were the papers favored by French printers and became the main papers at Tamarind Lithography Workshop in America from 1960 to 1970. These papers had stability and were less prone to deterioration than many fine rag papers that in modern times tended toward acidity because of the difficulty of controlling the chemical content of rags and local water. Other popular papers were those from the ancient mills of Fabriano and Barcham Green. The heavy German Etching (or Copperplate) paper was the standard support for intaglio prints. Most papers were available in two shades, one a creamy white, the other a warmer cream.

World War II, which had cut off access to the traditional Japanese and Chinese papers, led to the discovery, during the occupation of Japan, of papers that had not found their way to France three-quarters of a century earlier. Paper wholesalers found commercial uses for Japanese fancy papers (incorporating dried flowers, confetti, mica, etc.) and began to stock other unusual papers from Europe. From France came the textured papers of Angoumois, often distinguished by undigested threads or other imperfections. Individual papermakers, whose meager work in their mills was favored by small-press printers for slim books or invitations, offered their sheets to artists for drawing and occasionally produced enough paper with an acceptable standard of conformity for an edition of prints.

As artists gave more attention to the paper upon which their works were printed and publishers were able to order paper with specially designed watermarks for each important production, the craft of papermaking expanded. Embossing or inkless intaglio printing revealed hitherto unexplored dimensional capabilities of paper. Custom-colored handmade

paper was something small manufacturers could offer along with desired size, texture, and shape, thereby giving artists complete creative control over their prints. The inevitable following step was the introduction of artists into the papermaking process itself, allowing them to conceive and accomplish compositions in paper pulp, dyed and shaped to their specifications. These areas of artistic craft are not part of the subject covered here. However, they have often involved printers and occasionally have combined with printing. The paper projects undertaken in America by Gardner Tullis and Ken Tyler have had some importance for the evolution of printed art.

It seems a long distance between the craftsman-oriented fine-print techniques and those of the commercial world. We have seen how long it took for silkscreen to be formed into a medium that perfectly embraced the art mannerisms for which it was used. During this recent period rubber stamps and most of the photomechanical processes that ultimately are printed with ink on a press, as well as the light-activated printing techniques of Ozalid, blueprint, Xerox, and 3M, have been utilized by artists for multiplying their images. The open attitude toward these media is already indicated in Robert Rauschenberg's earliest printed works: a blueprint of a female figure of around 1949 and the *Automobile Tire Print* of 1951. Economy was the impetus behind the use of blueprint, and the direct printing of a rubber tire was an action influenced by and created with John Cage, an innovator as much in the visual arts as in the auditory.

At the beginning, the rubber stamp had the same aesthetic appeal as other found objects that could be applied to a surface. Its difference was, of course, that it could be inked and stamped repeatedly and in varieties of colors and densities. It was used, ready-made, to enhance drawings and collages, and was also transferred to other print media for extended and controlled printing. In 1964 Bill Katz issued a book of rubber-stamp prints, the commercially molded stamps designed by his Pop artist friends, entitled *Stamped Indelibly.* Stamps manufactured for children, in the form of Disney characters, animals, and war toys, populated the works of younger artists in the late sixties as accents for their protests. The casual aspect of rubber stamp as a repetitive yet personal tool for printing made it a suitable medium for such unofficial circumstances, but it was only when conceptual artists such as On Kawara used it for their serial ideas that the rubber stamp was made to carry out its traditional function as an authoritative, intrinsically boring transmitter of information.

The photographic media are rarely included in selections of printed

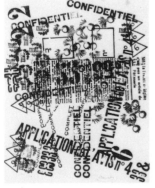

ARMAND P. ARMAN.
Cachets. 1956. Rubber stamps, 10⅝ x 8¼" (27.0 x 21.0 cm). Collection the artist.

material because the procedure of printing — that is, setting ink down on paper — is not similar to the chemical changes that in photography transform a piece of paper from white to varying shades of gray. In most photography the form that allows light to initiate this change is actually a stencil, the negative of the image that has been exposed to light and captured on translucent material. In order to print photographs in quantity the stencil must be altered to allow for the passage of ink through it (silkscreen) or transformed into an ink-carrying unit (the so-called photomechanical processes of line block, photolithography, and photoengraving). The stencil can also be a magnetic device in electrostatic photocopying machines.

One aspect of printed art that would exclude pure light-induced photography from our study is the contemporary artist's interest in mass production. Photographs have become, for many artists who make printed art, merely objects which, like a chair or face, are used in image-making. Light-activated processes, from the earliest simplicity of the camera obscura to the ultracomplex technology of xerography (and its permutations), utilize arranged material. The single photographic image, born from the photographer's selection of visual material and method of rendering it through the mechanical and chemical assistance of camera and developer, has a stronger formal and philosophical relationship to unique works of art such as drawing and painting. The contemporary artist who uses printing techniques appears to prefer to extract from the photo-processes rather than develop them further. In conceptual works photographs are forms of evidence leading, ideally, to the viewer's awareness of matters extrinsic to their aesthetic content. This function of photography perhaps enables one to understand the interest so many artists have had in the photocopying machinery of the past three decades. Those interested in process, beginning with Rauschenberg, have appreciated the illusionist translations of real objects permissible with blueprint and Xerox. Few works of this kind in these, until recently impermanent, media have had an importance beyond the experimental. The unaltered copying of drawn and printed material that has, to one critic's lasting scorn,[2] characterized the objectification of idea art seems to have more relevance.

2. Hilton Kramer, "Art: Xeroxophilia Rages Out of Control," *New York Times*, Apr. 11, 1970: "Now all they [aspiring artists] need do is write down their concepts, have their little bits of typescript xeroxed, and they will be in business." Kramer coins the word "Xeroxomaniac" in this review.

Though quite extensive, the foregoing report on the evolution of contemporary prints with reference to their media is nonetheless, I believe, fundamental to an understanding of the situation of art in this period. Without such an account, it is difficult if not impossible to explain how contemporary artists could have expended so much energy in creating works outside the studio and how they ultimately produced a change in attitude toward what art work is. Through their devotion to multiplicatory methods of applying their images many artists have altered and broadened expectations of the aesthetic experience. The proliferation of artists' books — not explanatory or justifying tracts on their work but the work itself — is the ultimate situation so far in this history of printed art. Moving into a changed relationship with society, one far more symbiotic than existed in the last century, the artist, like the minister of any ideology, has recognized that more than one technique is possible in the task of illuminating truth (if we accept that to be still the artist's calling).

The subjects and styles of art have been many and varied during the past two decades. Except for specialists in printmaking, artists customarily have begun to create prints only after they felt a certain mastery over the problems they set for themselves in their unique works. Until the period covered here these works were predominantly paintings, and it often was not until sometime in their mid-thirties that artists would turn to the print media. For this reason many of the ideas that appeared in unique works are reworked in the first prints they attempt. In 1962, the year when several young artists began to print on canvas, many other artists whose styles had developed in the late 1950s were introduced to lithography. At the same moment examples of geometric, abstract printmaking in colorful silkscreen began to appear. As artists became adept at the techniques and developed manners appropriate to the media, they incorporated printmaking into the total rhythm of their creative activity. Among the prints that appeared after this creative lag had been overcome are many that show the artist initiating ideas which are carried over into the primary medium soon thereafter. Printmaking became a major component in artistic expression of the sixties and seventies because artists could find in the various media and their work in them the solutions to problems of form, color, meaning, and all the elements that make up the composite of subject and style that is art.

Concurrently, many artists developed during this period without the traditional allegiance to a specific medium. Their attitudes toward the art object presupposed a different relationship to craft mastery. Selection of a

medium was interlocked with the image, so that many of the physical qualities of a work existed already in its subject. One must suppose that the existence of most idea, narrative, and/or conceptual art in printed form is implicit.

Much of the art of this period has been indivisible from print media. During the interest in Optical imagery attention was drawn to other areas of scientific representation, particularly the mathematically precise products of the computer. Like many other examples of highly technological experiment, computer-generated print remains one of the areas of investigation still relatively undeveloped. An understanding of the capabilities of this and other sophisticated automated print-producing mechanisms and how they may be used in the fertilization of ideas may not come about until the artist also understands the subjects implicit in cybernetics.

Seriality has been a basic subject for the printmaker since the first woodcut playing cards in the fifteenth century. Subsequent narrative or topographical sets of prints carried on this characteristic enterprise, which quite often ran parallel to the production of great series of paintings. However, series of prints were rarely meant to be shown together as wallpieces (until this century prints usually functioned as cabinet art, residing in albums, in boxes, or, occasionally, individually on a wall as a devotional image or a souvenir). The serial works of the 1960s, such as the *0-9* lithographs of Jasper Johns of 1962, Warhol's Brillo boxes and Campbell's soup cans of 1962, Robert Indiana's *Numbers* of 1968, and many of the sets of prints made by artists concentrating on retinal-response imagery, presented a changed point of view: in the case of numerals and geometric progressions, the idea was incomplete if all parts were not present; in the case of series of works which were nearly identical, the repetition of the image extended or added to the experience. The serial approach to art entailed an altered experience of time.

The manifestations of Dada and its grandchildren, the Happenings of the late 1950s which evolved as art forms rather than as theater, were part of an interest in expanding the subjects of the visual arts. The subject of time as it could be applied to static objects was explored by creating situations that extended the amount of time needed for viewing or experiencing them. Examining art works for links, for revelations of retinal affectivity, for subtle differences (activating the process of selection) is an experience that can be extended by such physical elements in the works as multiple parts. Print was the ideal medium: already a multiplier, it availed the artist a

matrix for either exact repetition, progressive changes in color, or additions of new elements. Attention to time also meant changing the rhythm of viewing art, and the introduction of language and documents demanded longer examination of the work. Instead of translating their ideas into the quick-registering symbols familiar from centuries of visual experience, the conceptual artists gave the viewer words, maps, and documentary photographs, often in book form, that were to provide both information and aesthetic satisfaction. These ideas, deceptively simple usually, were enhanced by repetition or presentation in identical units, so as to extend the amount of time needed for their examination. Artists' books became the most convenient means of presenting such work, beginning with Dieter Roth's series of *Bok* in the late 1950s and Ed Ruscha's booklet *Twenty-six Gasoline Stations* in 1962.

Artists' books as conveyors of visual material required a changed attitude not only toward what might be considered a work of art, but also about the procedure of making ideas become concrete, tangible, and visual. Both conceptual and Minimal art evolved as artists confronted the process of making art more directly. Having substituted real objects for their illusory painted counterparts in the 1950s, the artists in the 1960s set about examining the elements that made up a work of art. Conceptual artists approached the question of the art process by electing language over customary visual forms. Language presented as a visual form has long been a cultural phenomenon: in one of its mid-twentieth-century manifestations it has been known as concrete poetry. While conceptual artists preferred to conjure up the visible by means of the idea, they often presented such ideas in formats that were as fascinating as the ideas.

The paradox of much so-called conceptual art rests in the belief held by many of its advocates that the presentation of ideas in a mass-medium form (cheaply printed text, photography, and signs) would counteract the prevalent commercialization of art. As distasteful as the merchandising of their products had become, many artists, believing that they could divorce themselves from the market, still were unable to refrain from making their ideas material in some way. Eventually many who had typed file cards, xeroxed drawings, published linguistic discourses in unpretentious magazines, and sworn never to make "art objects," directly acknowledged the evidently primordial habit of humans to retain or collect by producing limited-edition wallpieces, As Mel Bochner aptly wrote in contradiction to conceptual purist Joseph Kosuth's remark "Execution is irrelevant," "There is no art which does not bear some burden of physicality."

At a time when artists were perceived as paragons of virtue and seemed willing to forgo material return, forecasts of an elevated plane of expression where only ideas had value appeared reasonable. A moral reassessment of the twentieth century was universal in the 1960s, and among the younger artists the reaction and its residue were cataclysmic. The idealism of youth, focused by political events and social inequities, exploded into radicalism and nihilism. The classicist idea art, dissociated from objectification, evolved on a route parallel to politicized, *engagé* art events and objects.

In Europe the eruption of political disturbance was reflected in some of the works of older artists who, unlike many of the children of World War II, had experienced an affiliation with social struggles. The Catalan artists Miró and Tàpies, in whose works symbols linked to ideas of freedom and oppression were constantly present, responded to the upheavals of the 1960s. The compelling slogan of the May 1968 student uprising, "Power to the imagination," was a call for reappraisal of the artist's role in society. The generation of artists involved in process and action such as Rauschenberg, Vostell, and Beuys focused the protests of the alienated through selected documentation of real and prepared events. Because the news media persistently bombarded the public with their condensed images of broken bodies and dehumanized instruments of management on battlefields and city streets, these images were added to the material from which artists selected their subjects. The martyrs of the black liberation movement in America, the epiphany of Ché Guevara, the manifestations of student militancy which nearly replaced the labor strike as the populist arena for social struggle, the pathetic residue of wars fought for ideals and concealed interests, the assassinated figures of political power and the crushed victims of natural phenomena — all these, through the homogenizing process of the media, were ready-made graphic material.

The most indelible print of this disaffected period is Richard Hamilton's *Kent State*, a silkscreen made from photographs taken of a television broadcast of the demonstration and tragedy of 1970. A sophisticated reworking of the media involved strengthening the film to video to film to screen image and, in the process, emphasizing the degradation (a reference to diminishing photographic clarity) of the scene. Even more abstract than the mass-media image from which it evolved, the print presented a specific viewpoint through isolation and media manipulation.

Many conceptual artists began to create their own forms of guerilla warfare during the late sixties. Their stand was essentially philosophical,

showing preference for ideological confrontation with the system (Hans Haacke and Daniel Buren) and criticism of its values (Marcel Broodhaers and Les Levine). In a description of Fluxus, the first major group of artists whose work was described as conceptual, one of its later associates wrote, "Concept art is not so much an art movement or vein as it is a position or world-view, a focus for activity."[3]

On the nearly opposite side of the orbit of visual expression have been the forms of abstract art usually referred to as Minimal and systemic. A predominant attention to material and to simple geometric forms has characterized the sculptures and paintings of Minimalists, who often present their work in series or groups to emphasize procedural differences and similarities. In print, as mentioned before, serial presentation is easily achieved. The quasi-conceptual art of Sol LeWitt, the ideas of which require materialization, calls for a series of actions that can be accomplished by executing one or a few etching plates and printing them apart, together, in different directions or in different colors. His more recent prints incorporate written directions for the drawn portions or presume the spectator's discovery of the system used. In this type of art the process of deduction on the part of the viewer becomes a correlative to the process of creation, the former requiring sharp perceptions and the latter requiring exact execution. Remote as are Minimal and systemic art from the engaged expressions that led to and responded to events, they have close ties with other forms of idea art. Many of their practitioners make clear in their work the structure or formula from which it evolved, putting into simple physical form rudimentary ideas, the ultimate alliance.

Following the examples of Yves Klein and Ad Reinhardt, Minimal artists often have presented their works in monochrome, subtly manipulated to activate perceptions of surface, edge, and structure. Before his death in 1967 Reinhardt had put his black compositions into silkscreen, but the colors that were used to contrast the usually barely perceptible interior geometric forms were too visibly different. More control over the print media has allowed artists like Robert Ryman in America and Gotthard Graubner in Germany to achieve the nearly subvisual contrasts they required. Both artists have created quite clear statements about the surface and edge of painting and have made equivalent representations in print.

3. Ken Friedman, "Notes on Concept Art" in *Seven Xeroxed Leaflets* (San Diego: 1971); quoted in Lucy R. Lippard, *Six Years: The Dematerialization of the Art Object from 1966 to 1972* (New York: Praeger, 1972), pp. 258–59.

Although many artists with an interest in process have radically altered the customary relationships between the printed image and its support, the Minimal artist often heightens the traditional print-to-ground dependence by concentrating most of the manipulation of the printed surface at its edges, thereby incorporating the unprinted margins into the spatial integrity of the work.

The definition of space has consistently been a major concern in art and became an isolated subject for intensive study during the period under consideration. Moving away from illusion, artists sought tangible references to the given or prevailing spatial elements: the edges and flatness of canvas, paper, lithographic stone, or copper plate; the floors, walls, ceiling, and corners of a room; the street, sidewalk, buildings of a city; the soil, water, atmosphere of the natural environment. The treatment of space may be in an impermanent form, and it may be in remote areas as well. The documenting of the transformation or composition of the landscape, in the forms of film and print, is a functional part of the work in many cases. The sketched and photographic views of Christo's mammoth compositions with cloth or Smithson's *Spiral Jetty* have fixed the works in time or historical space as well as expanded their existence in physical space through a multiplicity of viewpoints. Interior spaces have been composed through wall painting, film projection, lines drawn on surfaces or suspended between them, obstructed passages, etc. Interior space is used as the locus for space-defining actions taken by the artist or the visitor, often guided by printed instructions. There are also printed versions of some of the transitory works, such as the portfolios of Palermo, the late German artist whose printed sheets provide the elements for do-it-yourself installation. More often the two-dimensional works of such artists are the plans for installations in preexisting spaces and as such include the viewer in the process of definition. Map-reading, measuring, and calculating are among the many familiar cognitive acts that have increased the art viewer's awareness of spatial relationships. Through an emphasis derived from the context in which it is placed, a book containing two parallel vertical lines on each of twelve pages (Peter Downsbrough, *Two Lines*, 1978) becomes an authoritative guide to the understanding of spatial realities.

The use of the photographic image has been a sort of basso continuo in the preceding explication of printmaking. Photography, from the moment the artist confronted it and the general public embraced it, has had a widespread effect upon the way things are perceived. In the nineteenth century — that is, from its early stages — photography was used as a visual

aid or guide. One could record a person or object as an immutable model, extract compositional relationships from its automatic two-dimensionalizing of a subject, and discover infinite varieties of illusions in its unusual perspectives or its translations of light and shade into whites, grays, and blacks. Subsequent expansion and modification of the photographic medium led to its further utilization by the artist, particularly since it was adapted to the printing technology referred to earlier. Photographic imagery proliferated and has had, without a doubt, its greatest influence upon the art objects made in the sixties and seventies. Pop artists generally borrowed the photographic image after it had been processed through one or another of the mass printing techniques. Even though many of them made their own photographs, these were produced as part of the primary art works, not as secondary reference material. Nevertheless, the proto-Pop and Pop artists anchored most of their work in the preprocessed, automatic, and specific imagery that only the camera could capture.

Photo-Realism was a hardly unexpected successor to the indirect and perhaps more digested revelations of Pop art. Since the Depression, and particularly in the 1950s, verism had been the foundation of most photography, and painters began to recognize that the images in these photographs that captured the bitterest cracked door, the harshest suburban sun, and tiredest time-creased skin incorporated illusions that were possible subjects for their work. Elements such as the shallow field of focus and homogeneous surface were emphasized and exploited by painters. Working directly from their own photographs, many were able to imprint upon their compositions most of the features that extended the impression of reality proffered by the camera.

Chuck Close has used a grid system to break down into small units the photographed portraits of his subjects. In his prints, though not in his paintings, this system remains visible, each small square containing the amount of light and shade, accomplished through mezzotint or line etching, that will be perceived as the depiction of Photo-Real form. Close uses a kind of trompe-l'oeil that works only because contemporary eyes are accustomed to forming larger units out of such particles as the screen-formed dots of photomechanical printing and the constant linear "print out" of television.

The spectacular gymnastic capability of the eye, which, unlike the camera, presents us with multiple impressions simultaneously, jumping around in space and penetrating superficial barriers, is recognized by

artists who use the camera to control their point of view. Reflective surfaces dominate the screenprints of Richard Estes, who does not allow the eye to make its customary instant penetration of the store windows and chrome trimmings that reflections have partially transformed. Awkward perspective, resulting from the static placement of the single-eyed camera, has also been a subject of representation in figurative art.

Throughout the period of this survey figurative art has persisted in many forms. Besides the secondhand reality of Pop art and the Photo-Realism described above, a vital current of representing humans and their surroundings has continued to run through art. Much of this work is what is historically referred to as genre art: it depicts a life-style in a manner suitable to the subject. David Hockney's prints are typical examples of this mode, both in his choice of subjects (moralizing tales, human still lifes) and his method of representation (flat, linear, easily deciphered forms similar to early twentieth-century comic-strip drawing). A distillation of form and event into a story-telling tableau characterizes much of this kind of figurative art.

This simplified, styleless, and (therefore) possibly universal method of representation may supersede pure abstraction as a means of international communication in art. No longer enchanted by science, which in the late 1970s seems to have created more problems than it has solved, many artists find preindustrial cultural relationships to the natural environment better sources for inspiration. The lack of a specific personality to this art has contributed to considerable confusion in its explication. At best it fits most neatly under the broad but constantly reinterpretable umbrella of humanist expression. This art attempts to clarify life in the most unambiguous terms. The drawing of primitive societies, which not only depicted human activity but made the action of depiction a ritual of the society, has been an influence in the trend. For over two decades Anton Heyboer has incorporated art-making into his natural pattern of activity, recording in print and paint the events of his daily life as they occur. Such art is one of natural incident unencumbered by historical references or evolutionary conformities. Other manifestations of this search for elemental representation occur in art that exploits serial decorative elements (primarily those associated with religions that forbid figurative imagery and those patterns traditionally made by women, as in quilts, weaving, and needlework). This humanistic rootedness, refracting society into its fundamental parts, has produced art that urges contact with human spirit and mind in a balanced relation.

It is possible that an adequate sense of contemporary printed art may be acquired from a discussion of its manufacture and appearance and from a comparison with work of the past. Although reference has been made already to the sociological and political linkages that have formed the subjects of some of the works, larger issues of historical attitudes toward what art itself is have been dealt with only in terms of physical differences. The art of this period, according to some critics, is filled with ambiguity in comparison with other creative products as the result of its institutionalization (by the capitalist system as manipulator and/or by the museum as legitimizer). Many artists, preferring to practice philosophy rather than craft, incorporate into an activity still called "art" specific attitudes that negate past justifications for materializing ideas. This is not simply Joseph Kosuth following his chosen subject "Art as Idea as Idea" into a very concrete corner. It is a direct refutation of the fundamental structure of art, the basis upon which myriads of dissimilar elements form into perceptible patterns that, when called art, have until recently been essentially visual. Slowly, much of the actual work of art has found its existence in actions, the residue of which may or may not corporeally remain, and may or may not incorporate references to the action or even its ideation. The postcards and telegrams of On Kawara record his daily actions, but their existence in space is less important to the art work than the continuity of the action. The artist often depends upon the audience to complete an action, as in the surveys of Hans Haacke and the inquiries of Stanley Brouwn.

Duchamp, who legitimized as art his choice of ready-made objects, focused upon a fundamental element in perceiving the characteristics of art: the ego of the artist. The Duchampian context becomes synthesized by John Cage and Robert Rauschenberg in the *Automobile Tire Print* of 1951. The content of the work is not only the ready-made object (tire) that made it material but, equally, the action of the artist directing Cage to drive over the long sheet of paper. Therefore, this past episode in the work of art is part of its structure, but such action taken by anyone else (certainly car tires have left tracks upon billions of sheets of paper) would not be acceptable as art. Taking Duchamp's idea from another viewpoint, artists questioned the need to legitimize objects through their advocacy. Instead they chose to surround, encase, or obliterate what might have been creditable in the Duchampian sense. Whereas Duchamp isolated an object and declared it art, artists such as Broodhaers and Buren isolated the spectator from the object, and have created their art out of an experiential alteration in expectation. To the average person who goes

ROBERT RAUSCHENBERG
(with John Cage).
Automobile Tire Print. 1951.
16½ x 264½" (41.9 x 672.2 cm).
Collection the artist.

through life using objects as guideposts to time and space, accepting them as tangible representatives of a sociopolitical environment, an analysis of this relationship to objects does not necessarily lead to social self-awareness or any other heightened perception of communal inter-dependence. By withdrawing the object from one plane of acceptance and introducing such temporary elements as political confrontations that might result (chance) in ensuing action, some contemporary artists have made an effort to rebuild the structure of art, which they felt did not fit into the perfect society they envisioned.

It is not surprising that the context in which this revision was most dramatically encountered was the museum exhibition. About a decade ago the confrontation definitively changed the manner of art presentation, but its impact remains diminished by the passive and materialistic attitudes that continue to prevail among most art spectators. Artists removed their work from the context of the museum by confronting the institutional system with political action, making concrete works that could not be moved into a building or that would endanger its audience, and creating works in printed or temporary forms that could be better examined in another setting (an armchair at home or an open space). It is significant that most of this took place during a period when institutions housing cultural activities were vigorously expanding in America and in Europe. Such institutions often developed without artist participation, and this factor must have reinforced an already pervasive alienation in that segment of society. The reaction was to challenge the object orientation of art.

One returns then to this object, enhanced and extended by newly recognized virtues, accessible to more people because its basic elements are shared with other areas of human concern. The broadening experi-ence of art rests more often than not in the area of printed matter, where the sociopolitical context is ever-present. Whoever said one picture is worth a thousand words did not live in the vulnerably literate late twentieth century. Television's visual pervasiveness was the competition, Mao's Little Red Book was the model for change. By no means was the model chosen solely on political grounds; it had more vitality than pictorial material which, because of television's encouragement of visual passivity, necessitated increasing amounts of shock treatment. Artistic expression fragmented itself further as pictorial and sculptural objects moved closer and closer to representations of reality that required less and less audience concentration, while actions, books, and eventually the television medium itself were used to engage far more rigorously those who found little

stimulation (emotional or philosophical) in those simulations of reality. Through most of this century discipline has been considered a questionable and even detrimental means of child-rearing, for it has inevitably been associated with punishment. Clearly the artist who requires society's participation in the completion of an art work involves that society in a precisely disciplined activity which contains and makes relative all varieties of independent associative interpretations. The swing away from art that provoked the imagination and encouraged personal interpretations began with Pop art (aptly named New Realism by the Europeans). Since that point artists have limited the amount of uncontrolled subjective association that their work might engender, while attempting to make the experience of such work sufficiently intricate to elicit appreciation.

Rauschenberg and Johns, by trapping pieces of the vernacular within structures held together by expressive components, led the way in the attempt to reunite art and life. In the more than two decades since this tendency toward reification gained momentum, the fundamental goal of many artists has been to achieve accessibility to the daily existence of all mortals. Awareness of population growth and ecology, of mankind's ability to destroy itself in the attempt at bettering or balancing the two, has added momentum to the artist's search for communication.

It is possible to regard artists of our time in the role of teachers,[4] showing society that by looking it can see better, by reading it can know more about how and why it acts, by moving through spaces it can become aware of its own size and existence. It may be too much to ask of ink on paper, this printed work that has not spread as far into the crevices of society as it idealistically was meant to, that it transform the nature of humankind. However, in the use of materials invented so long ago to do exactly that, artists reaffirm their role in society to communicate. As one reviews the artistic expression of the sixties and seventies, it is the prevalence of printed art that is the hopeful indicator of this enlightenment.

4. Joseph Beuys: "To be a teacher is my greatest work of art. The rest is the waste product, the demonstration...At the moment, art is taught as a special field which demands the production of documents in the form of art works, whereas I advocate an aesthetic involvement from science, from economics, from politics, from religion — every sphere of human activity." Willoughby Sharp, "An Interview with Joseph Beuys," *Artforum*, Dec. 1969, pp. 40-47.

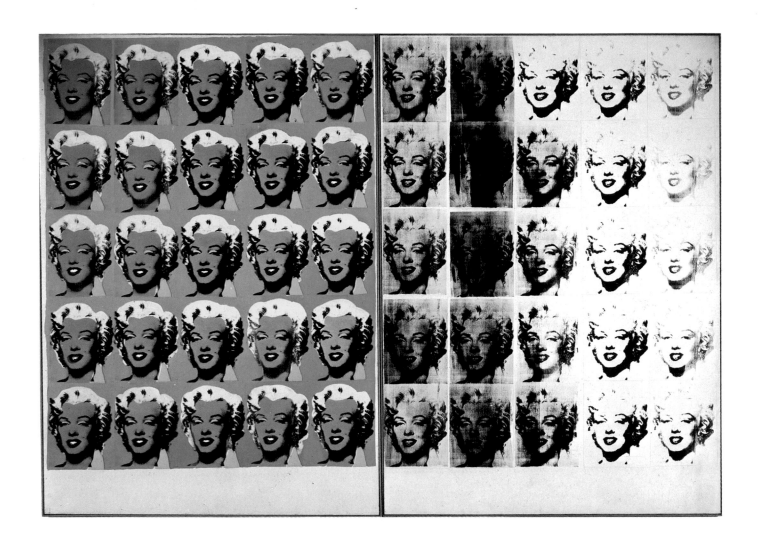

ANDY WARHOL. *Marilyn Monroe Diptych.* 1962.
Silkscreen, enamel, and acrylic on canvas,
2 panels, each 82 x 57″ (204.0 x 144.8 cm).

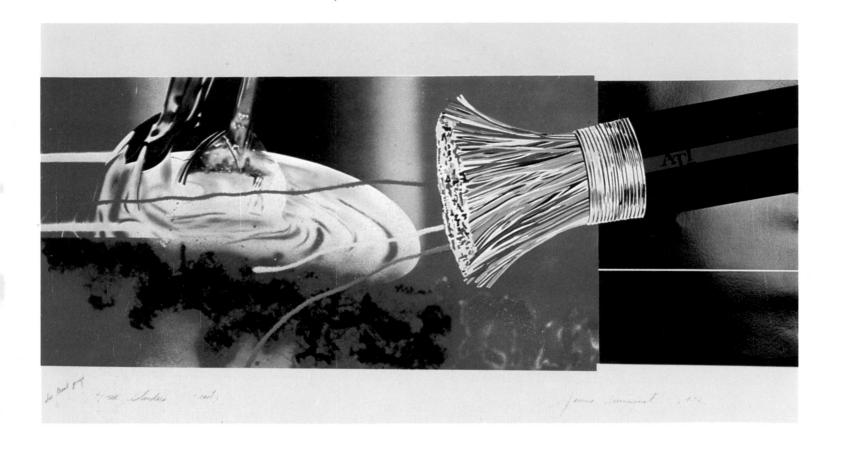

JAMES ROSENQUIST. *Horse Blinders (East)*. 1972.
Silkscreen and lithograph with collage,
36¼ x 67½" (92.0 x 171.4 cm).

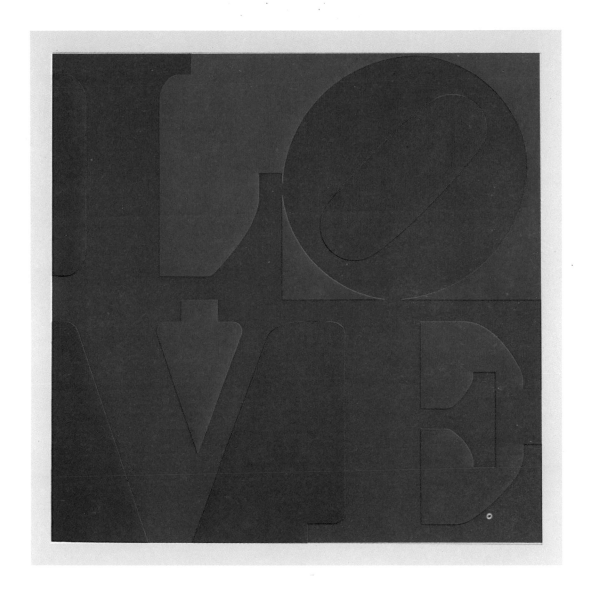

ROBERT INDIANA. *Love.* 1967.
Silkscreen, 36 x 36″ (91.4 x 91.4 cm).

DIETER ROTH. Four from *Six Piccadillies.* 1970.
Lithograph and silkscreen,
each 19¹¹/₁₆ x 27⁹/₁₆" (50.0 x 70.0 cm).

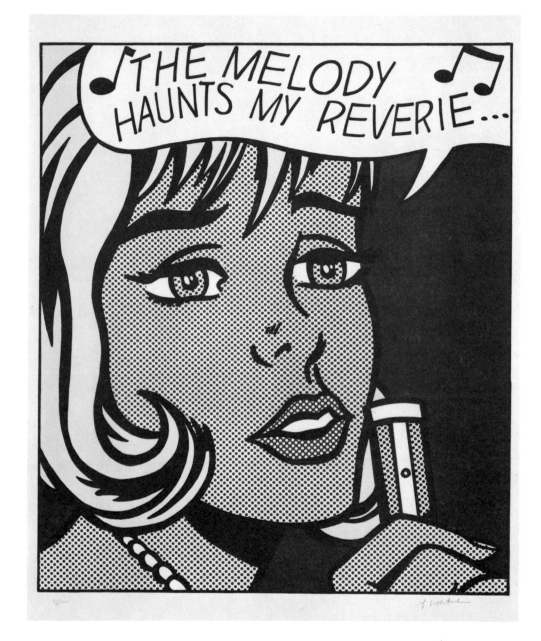

ROY LICHTENSTEIN. *Reverie* from *11 Pop Artists*, Volume II. 1965.
Silkscreen, 27⅛ x 22¹⁵⁄₁₆″
(68.9 x 58.2 cm).

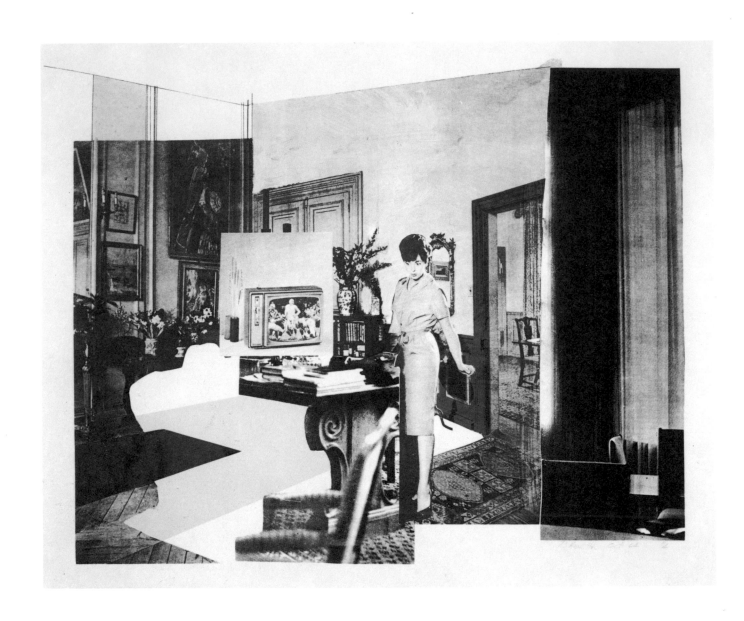

RICHARD HAMILTON. *Interior.* 1964.
Silkscreen, 19⅝ x 25⅛"
(49.1 x 63.8 cm).

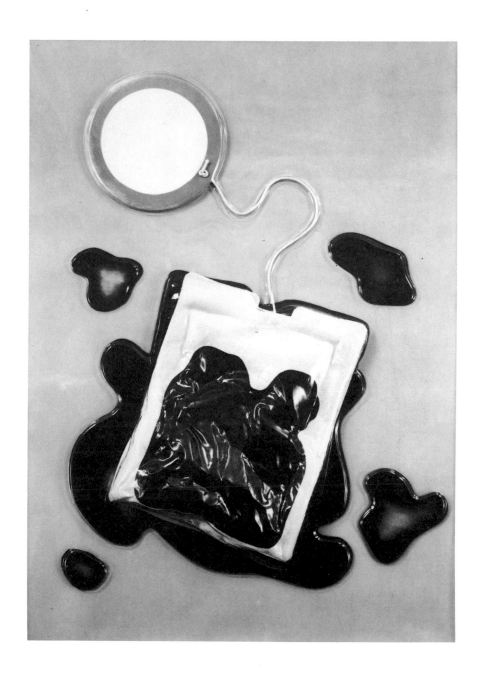

CLAES OLDENBURG. *Tea Bag* from *Four on Plexiglas*. 1966.
Silkscreen on felt, clear plexiglas and plastic,
39⁵⁄₁₆ x 28¹⁄₁₆ x 3″ (99.8 x 71.3 x 7.6 cm).

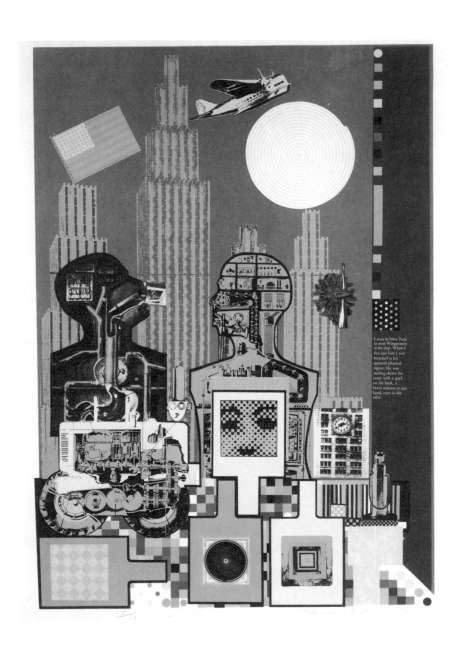

EDUARDO PAOLOZZI. *Wittgenstein in New York* from *As Is When*. 1965.
Silkscreen, 30 x 21⅛″ (76.2 x 53.7 cm).

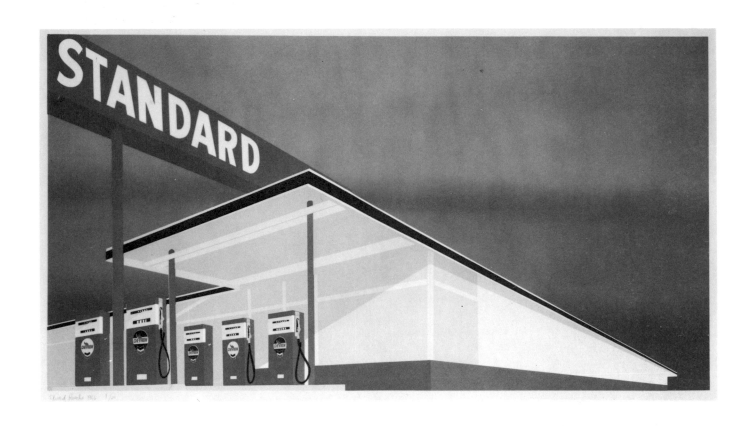

EDWARD RUSCHA. *Standard Station.* 1966.
Silkscreen, 19½ x 36¹⁵⁄₁₆" (49.5 x 93.8 cm).

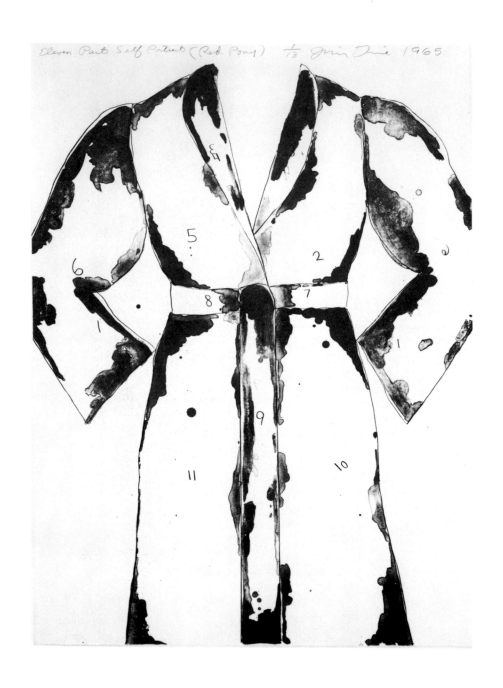

JIM DINE. *Eleven Part Self Portrait (Red Pony)*. 1965.
Lithograph, 39¾ x 29⅝″ (101.0 x 75.2 cm).

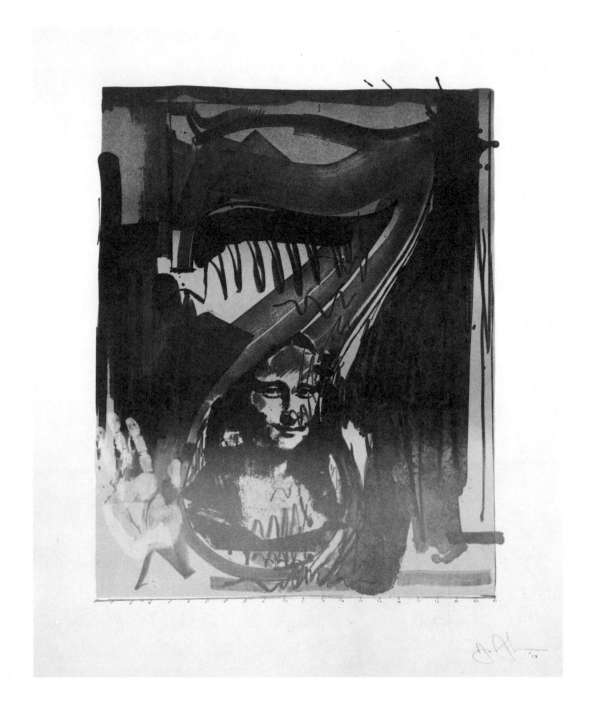

JASPER JOHNS. *Figure 7* from *Colored Numerals*. 1969.
Lithograph, 28⅛ x 22⅜" (71.4 x 56.9 cm).

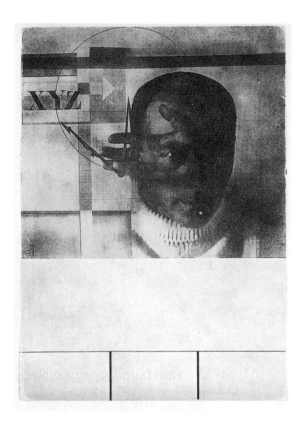

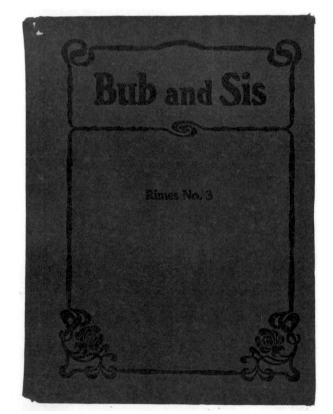

RONALD B. KITAJ. *Bub and Sis* from *In Our Time Covers for a Small Library after the Life for the Most Part.* 1969.
Silkscreen, 18¹³⁄₁₆ x 14⅞″ (47.8 x 37.8 cm).

RONALD B. KITAJ. *Photo-eye (El Lissitzky)* from *In Our Time Covers for a Small Library after the Life for the Most Part.* 1969.
Silkscreen, 21³⁄₁₆ x 15″ (53.8 x 38.1 cm).

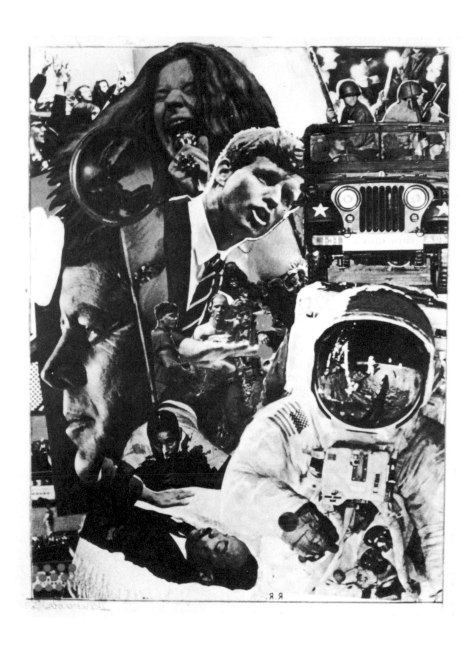

ROBERT RAUSCHENBERG. *Signs.* 1970.
Silkscreen, 43 x 34" (109.2 x 86.3 cm).

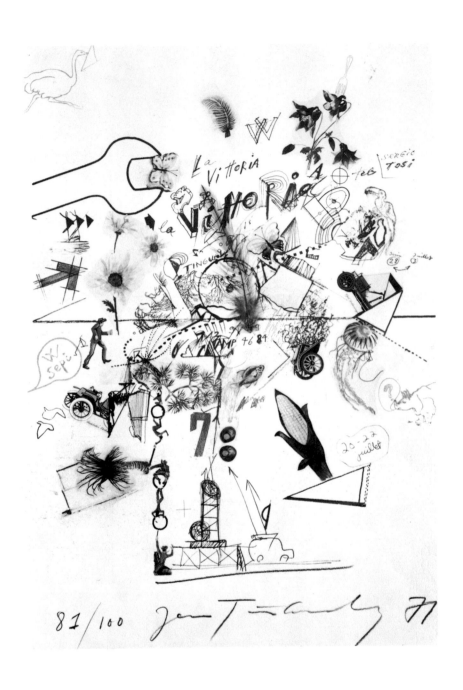

JEAN TINGUELY. Plate from *La Vittoria*. 1972.
Offset, rubber stamp, felt pen, pencil, decal, cellophane tape,
feather, 17⅝₁₆ x 13⅛″ (44.0 x 33.3 cm).

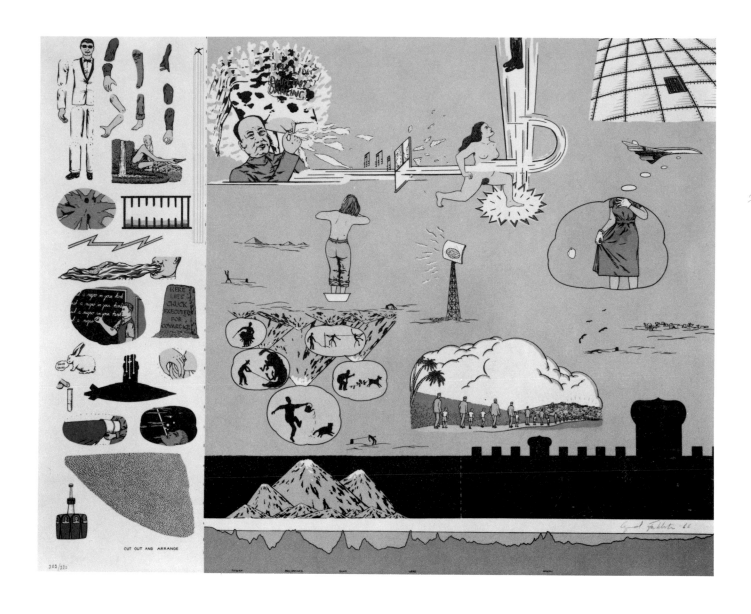

OYVIND FAHLSTRÖM. *Eddy (Sylvie's Brother) in the Desert* from *New York International*. 1966.
Silkscreen, 17¹/₁₆ x 21¹³/₁₆" (43.4 x 55.4 cm).

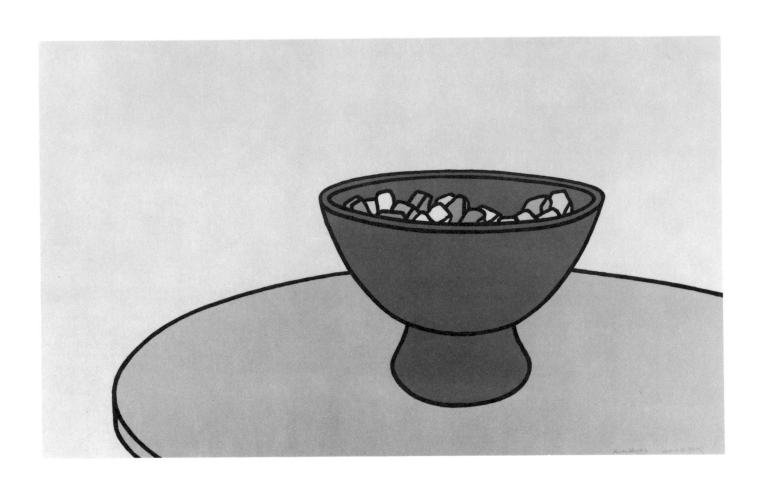

PATRICK CAULFIELD. *Sweet Bowl.* 1967.
Silkscreen, 22 x 36″ (55.9 x 91.4 cm).

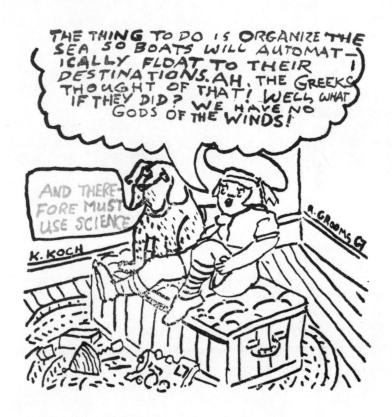

RED GROOMS and KENNETH KOCH. Plate 2 from *Stamped Indelibly*.
New York, Indianakatz, 1967. Rubber stamp,
11³⁄₁₆ x 8⅜" (28.4 x 21.3 cm).

HEINZ MACK. Untitled from *made in silver*. 1966.
Silkscreen, 16⅝ x 25⅛″ (42.3 x 63.9 cm).

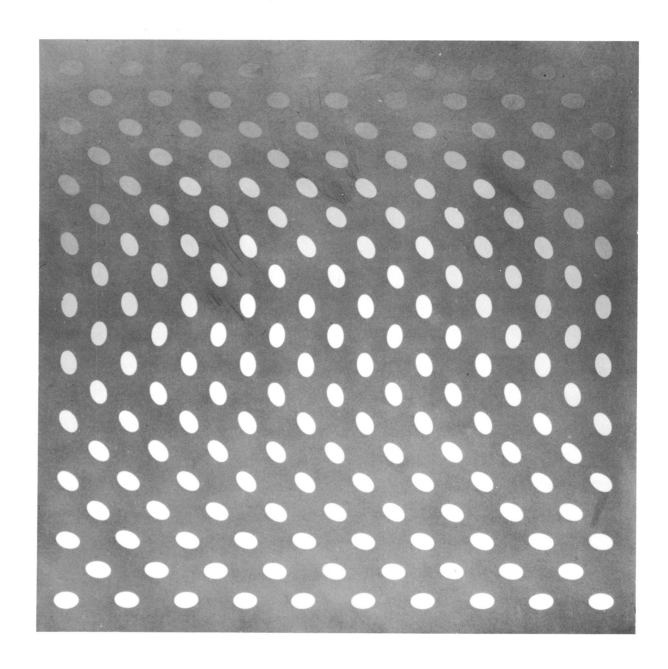

BRIDGET RILEY. *Print A* from *19 Greys*. 1968.
Silkscreen, 30 x 30″ (76.2 x 76.2 cm).

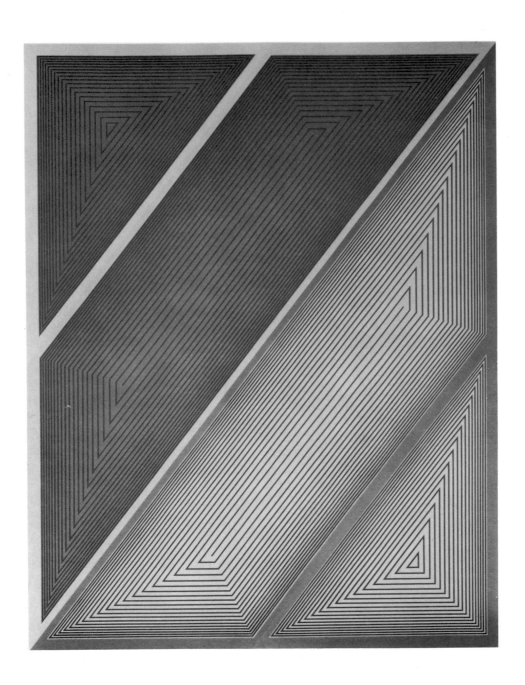

RICHARD ANUSZKIEWICZ. Plate 3 from *Inward Eye* by William Blake.
Baltimore, Aquarius Press, 1970. Silkscreen,
25¾ x 19⅞″ (65.4 x 50.5 cm).

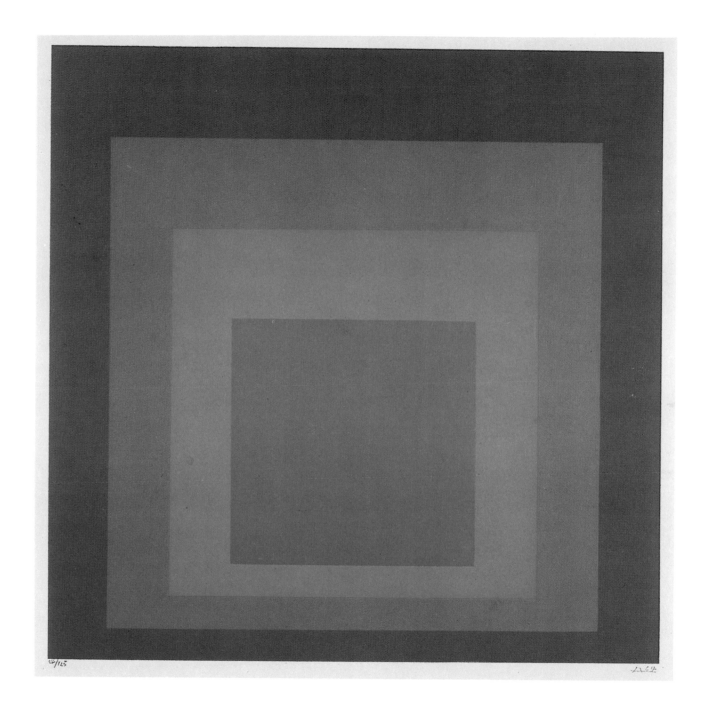

JOSEF ALBERS. Plate from *Homage to the Square.* 1965.
Silkscreen, 11 x 11″ (28.0 x 28.0 cm).

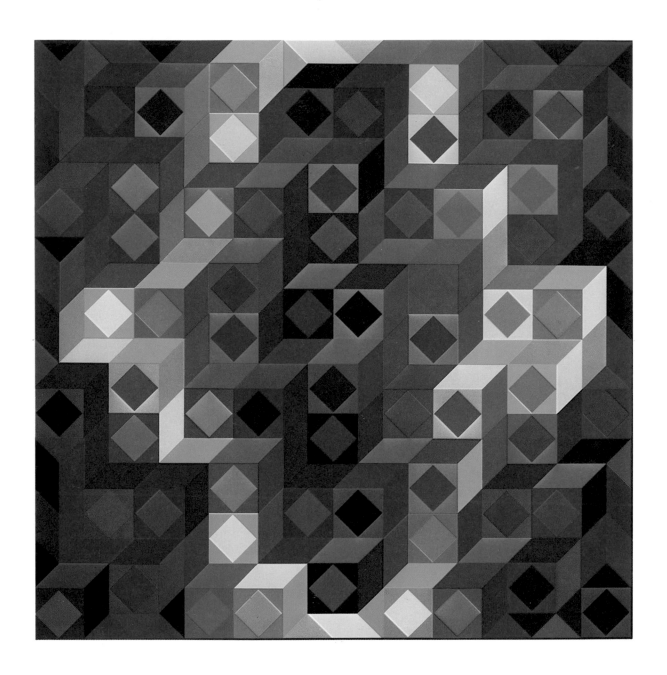

VICTOR VASARELY. Plate from *Homage to the Hexagon*. 1969.
Silkscreen, 23¾ x 23¹³⁄₁₆″ (60.3 x 60.5 cm).

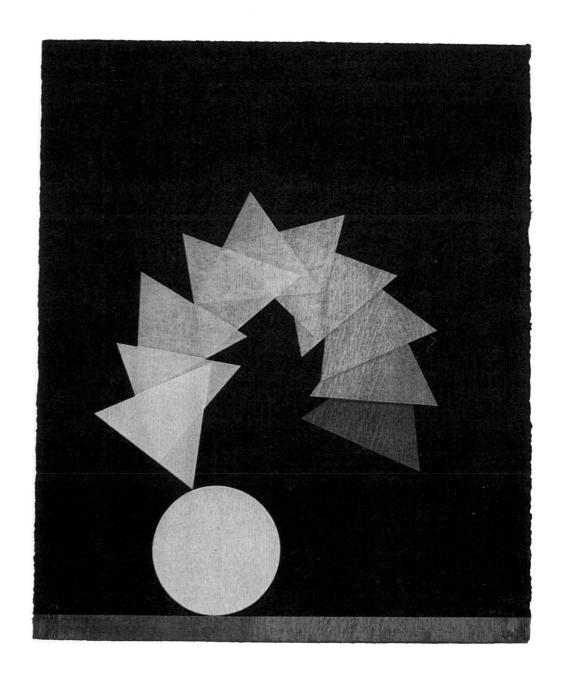

POL BURY. *Circle and Ten Triangles, Yellow-Black.* 1976.
Woodcut, 20⁹⁄₁₆ x 22⁹⁄₁₆"
(52.2 x 57.3 cm).

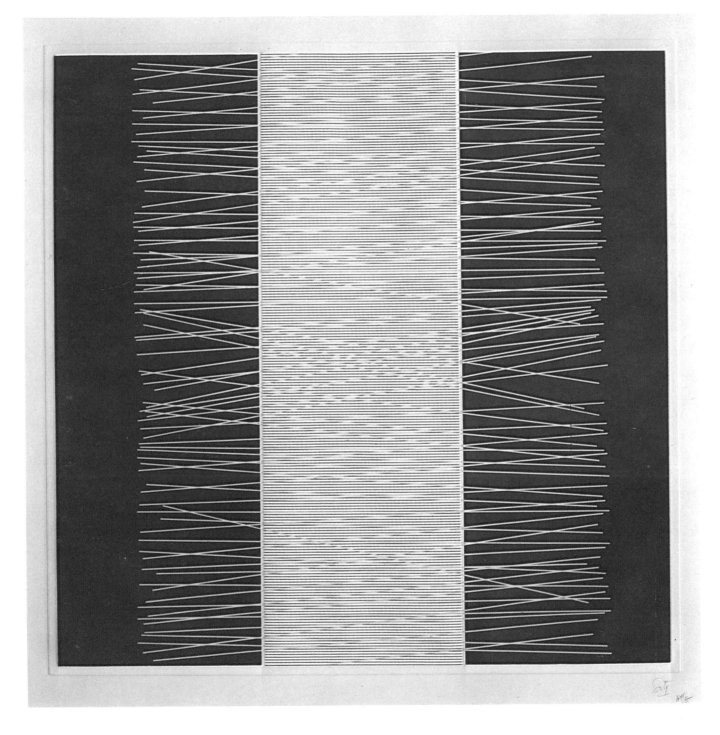

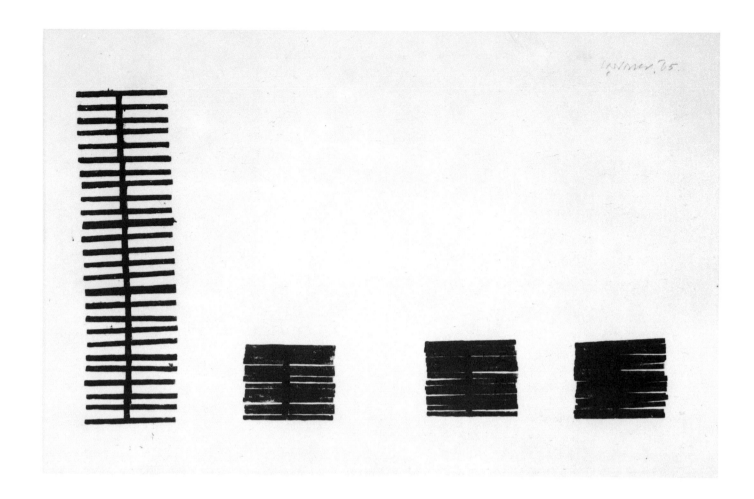

Left
JESÚS RAFAEL SOTO. Untitled B. 1971.
Embossed silkscreen, 26⅞ x 26⅞"
(68.2 x 68.2 cm).

Above
CAREL VISSER. Untitled. 1965.
Woodcut, 17¾ x 31½" (45.1 x 80.0 cm).

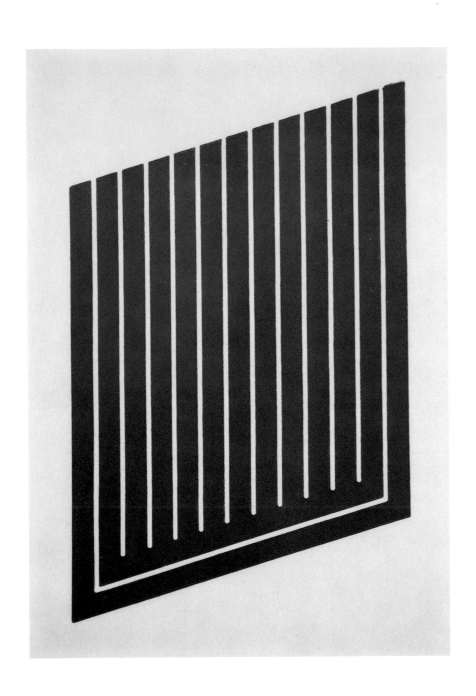

DONALD JUDD. *6-L.* 1961–69.
Woodcut, 25⅝ x 15¹⁵⁄₁₆″ (65.1 x 40.5 cm).

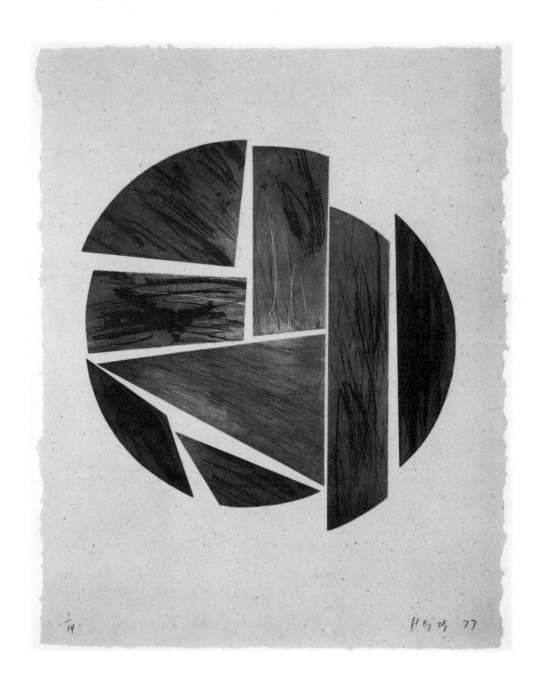

MICHAEL HEIZER. *Circle III*. 1977.
Etching, aquatint, and roulette,
26½ x 24¹⁵⁄₁₆″ (67.3 x 63.3 cm).

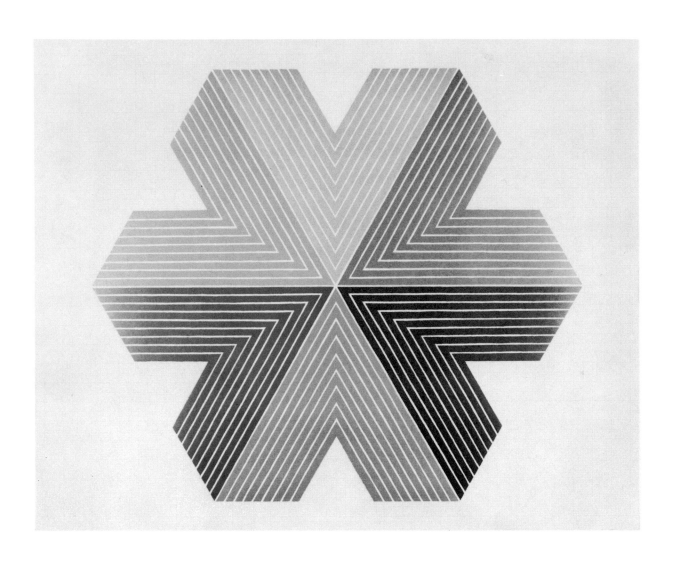

FRANK STELLA. *Star of Persia II*. 1967.
Lithograph, 22½ x 25¹⁵⁄₁₆″ (57.1 x 65.9 cm).

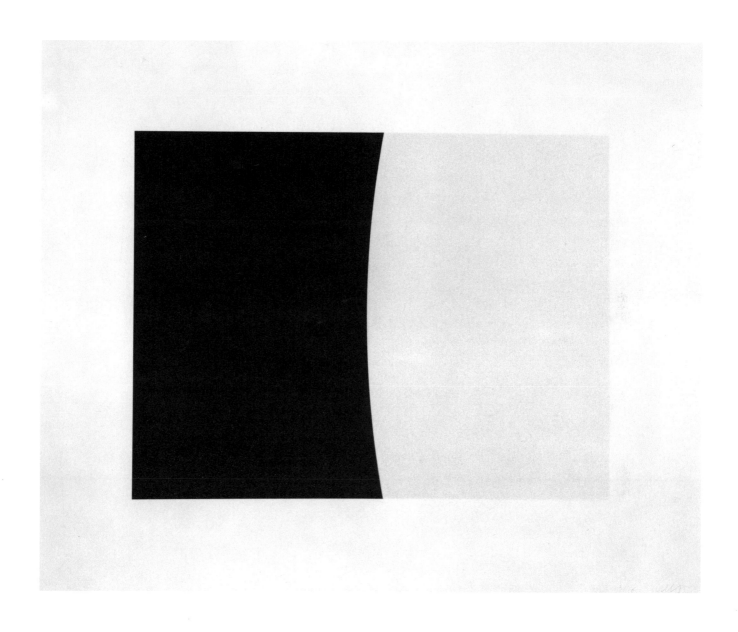

ELLSWORTH KELLY. *Germigny* from *Third Curve Series*. 1976.
Lithograph and debossing,
22 x 29″ (55.9 x 73.7 cm).

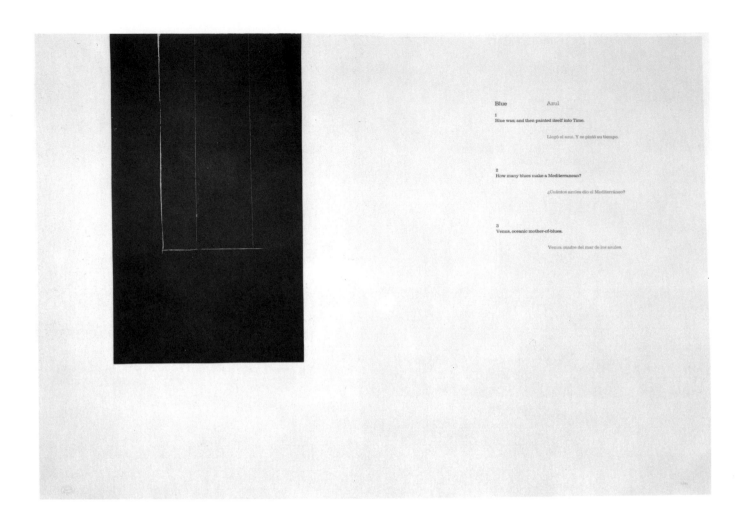

Blue Azul

1
Blue was; and then painted itself into Time.

Llegó el azul. Y se pintó un tiempo.

2
How many blues make a Mediterranean?

¿Cuántos azules dio el Mediterráneo?

3
Venus, oceanic mother-of-blues.

Venus, madre del mar de los azules.

ROBERT MOTHERWELL. *Blue 1–3* from *A la Pintura* by Rafael Alberti. West Islip, Universal Limited Art Editions, 1972. Etching and aquatint, 25¾ x 38″ (65.4 x 96.5 cm).

GV220PCS

FORT WORTH XXXXX NOV. 25 -- LEE HARVEY OSWALD, ACCUSED KILLER
OF PRESIDENT KENNEDY, WHO WAS HIMSELF MURDERED YESTERDAY, WAS BURIED
HERE TODAY IN AN ISOLATED SECTION OF ROSE HILL CEMETERY. THE
SERVICE WAS ATTENDED BY OSWALD'S MOTHER, MRS. MARGUERITA OSWALD,
HIS WIFE, MARINE, HIS TWO CHILDREN AND HIS BROTHER ROBERT. SECRET
SERVICE AGENTS RINGED THE GROUP.

DETERMINED TO AVIOD THE EYES OF THE CURIOUS, THE FUNERAL WAS
CONDUCTED WITH SUCH SECRECY THAT NOT EVEN THE GRAVEDIGGERS KNEW
THE IDENTITY OF THE DECEASED UNTIL THE SERVICE WAS OVER.
IW305PCS

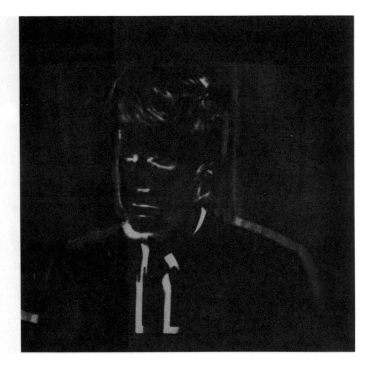

ANDY WARHOL. Plate 11 from *Flash* by Phillip Greer. Briarcliff Manor, Racolin Press, 1968.
Silkscreen, 20¹⁵⁄₁₆ x 20¹⁵⁄₁₆" (53.1 x 53.1 cm).

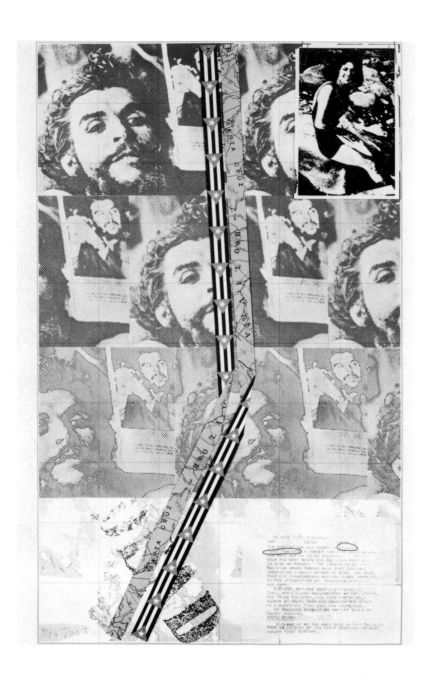

JOE TILSON. *Is This Ché Guevara?* 1969.
Silkscreen and collage,
39⅞ x 23¹¹⁄₁₆″ (101.3 x 60.2 cm).

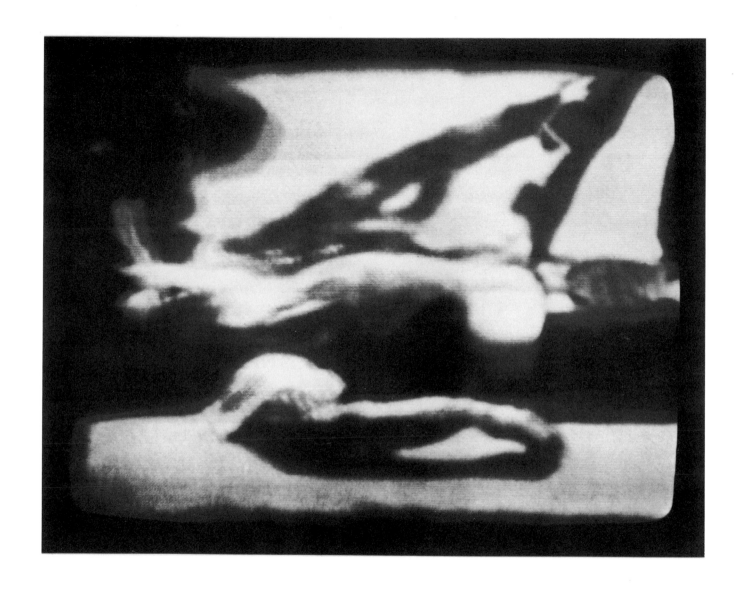

RICHARD HAMILTON. *Kent State*. 1970.
Silkscreen, 26⁷⁄₁₆ x 34³⁄₈" (67.1 x 87.3 cm).

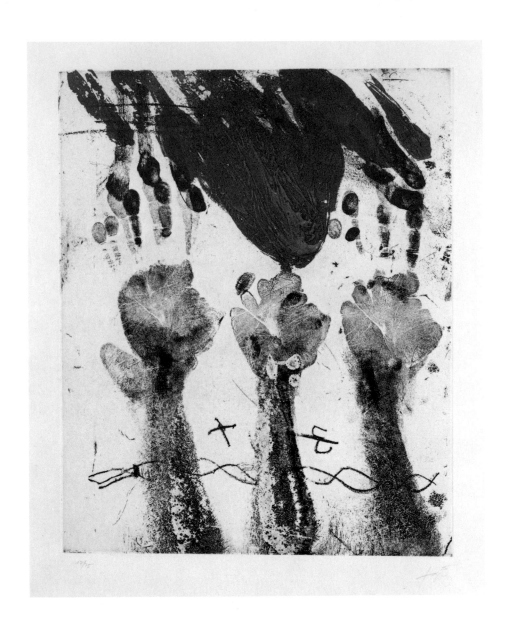

ANTONI TÀPIES. *Impressions of Hands.* 1969.
Etching and aquatint, 19⁹⁄₁₆ x 15½″ (49.6 x 39.3 cm).

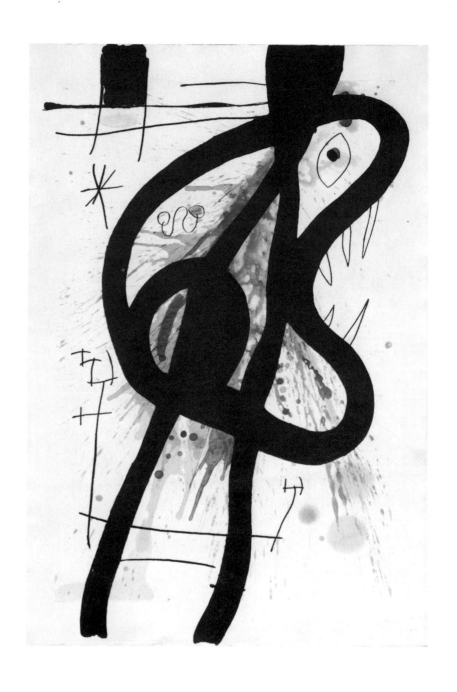

JOAN MIRÓ. *The Large Carnivore.* 1969.
Aquatint, etching, and carborundum,
36¼ x 23 1/16″ (92.0 x 58.5 cm).

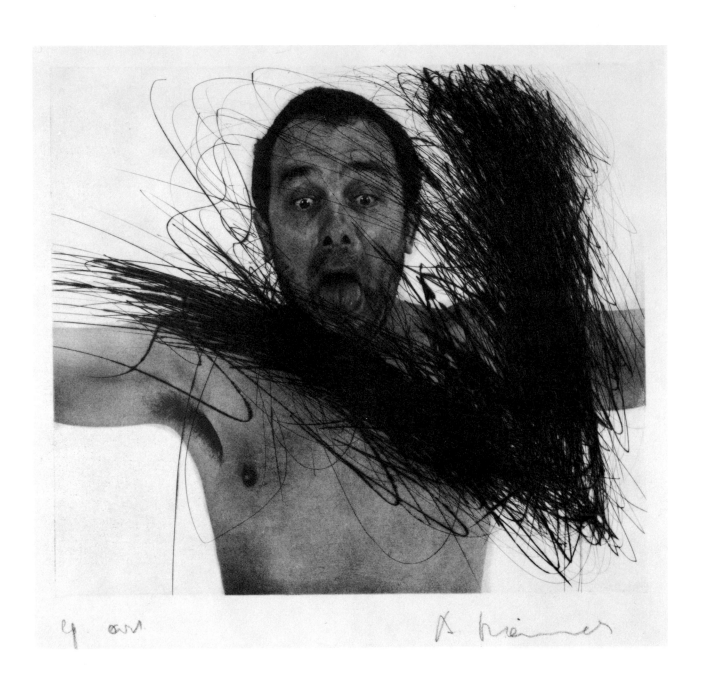

ARNULF RAINER. *Self-Portrait*. c. 1975.
Photogravure, etching, and drypoint,
11¹⁄₁₆ x 12½" (28.0 x 31.7 cm).

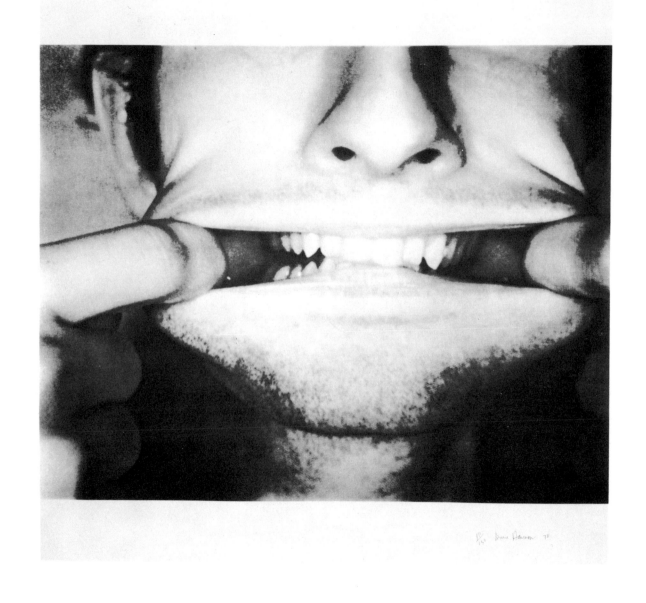

BRUCE NAUMAN. Untitled from *Studies for Holograms.* 1970.
Silkscreen, 20⅜ x 26″ (51.8 x 66.0 cm).

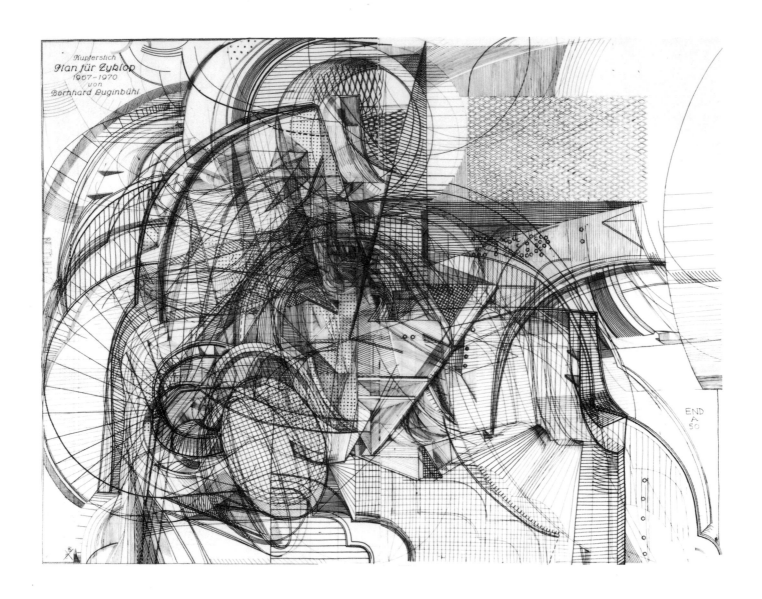

BERNHARD LUGINBÜHL. *Plan for Cyclops.* 1967–70.
Engraving, 30¾ x 39″ (78.2 x 99.0 cm).

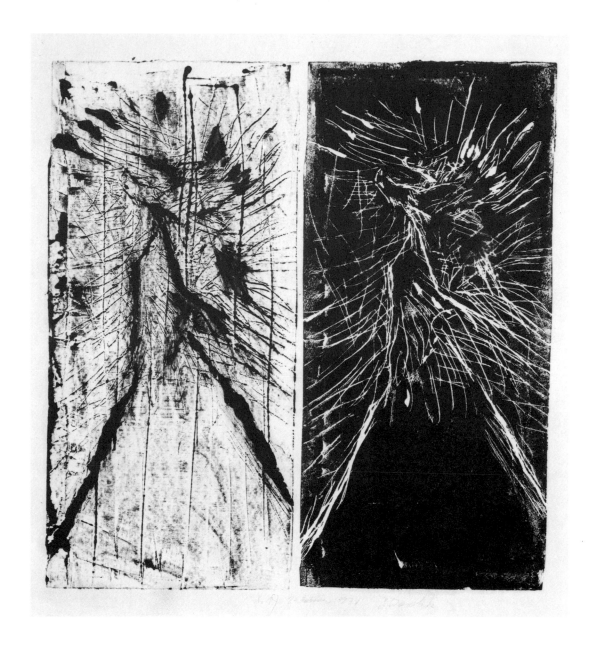

GEORG BASELITZ. *Eagle*. 1977.
Linoleum cut, 23⅝ x 10⅝″ (60.0 x 27.0 cm).

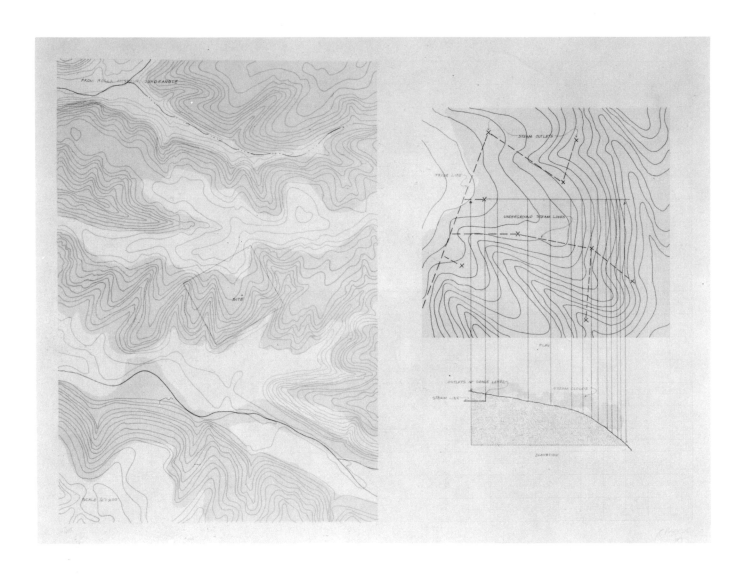

ROBERT MORRIS. *Steam* from *Earth Projects*. 1969.
Lithograph, 20 x 27¹⁵⁄₁₆″ (50.8 x 71.0 cm).

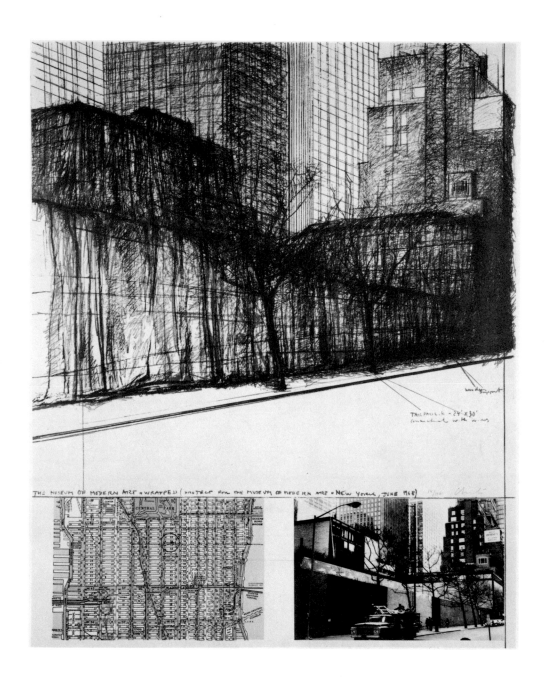

CHRISTO (Javacheff). *MOMA (Rear)* from *(Some) Not Realized Projects.* 1971.
Lithograph with collage,
27¹⁵⁄₁₆ x 22″ (71.0 x 55.9 cm).

LES LEVINE. *Conceptual Decorative*. 1970.
Silkscreen, 33⅛ x 41¹⁵⁄₁₆″ (84.1 x 106.5 cm).

MARCEL BROODTHAERS. *Museum*. 1972.
Silkscreen, 2 sheets, each 33⅛ x 23⁵⁄₁₆″ (84.1 x 59.2 cm).

VITO ACCONCI. *Think/Leap/Re-think/Fall.* Dayton, Ohio, Wright State University, 1976.
Offset, 8 x 8″ (20.3 x 20.3 cm).

JOSEPH BEUYS. *Minneapolis Fragments*. 1977.
Lithograph, 6 sheets, each 25⅜₁₆ x 35″ (64.0 x 89.0 cm).

ALFRED JENSEN. Plate from *A Pythagorean Notebook*. 1965.
Lithograph, 22⅝ x 16½" (57.4 x 41.9 cm).

ARAKAWA. *The Degrees of Meaning.* 1973.
Silkscreen and lithograph,
27½ x 18⁷⁄₁₆″ (69.8 x 46.8 cm).

MEL BOCHNER. *Rules of Inference.* 1974.
Aquatint, 22¼ x 31¹⁄₁₆″ (56.5 x 78.9 cm).

SOL LEWITT. *Lines from Sides, Corners and Center.* 1977.
Etching and aquatint, 34⅝ x 34⅞" (87.9 x 88.5 cm).

BRICE MARDEN. Untitled from *Ten Days*. 1971.
Etching, 12 x 15⅟₁₆″ (30.5 x 38.2 cm).

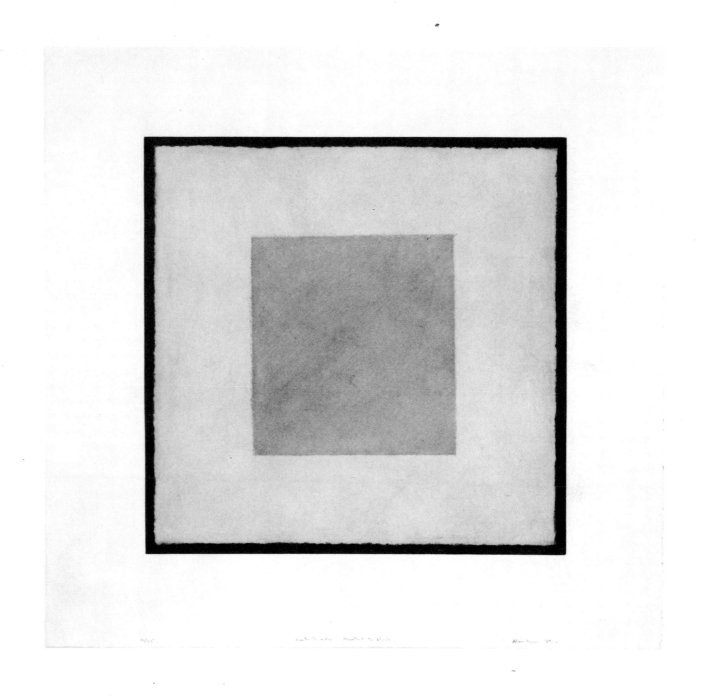

ALAN GREEN. *Center to Edge—Neutral to Black*. 1979.
Etching, 18⅞ x 18¹³⁄₁₆″ (47.9 x 47.7 cm).

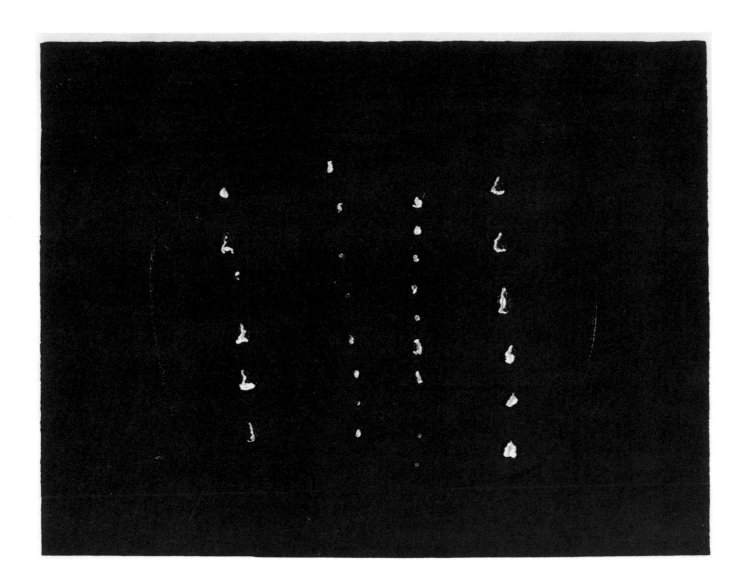

LUCIO FONTANA. Untitled from *Six Original Etchings*. 1964.
Etching and embossing, 13³⁄₁₆ x 16¾″ (33.5 x 42.5 cm).

TOM PHILLIPS. *The Birth of Art*. 1973.
10 etchings, each 11 x 22⁷⁄₁₆″ (28.0 x 57.0 cm).

SHOICHI IDA. *Paper Between Two Stones and Rock* from
The Surface Is the Between. 1977.
Offset lithograph and embossing,
37 x 23½" (94.0 x 59.7 cm).

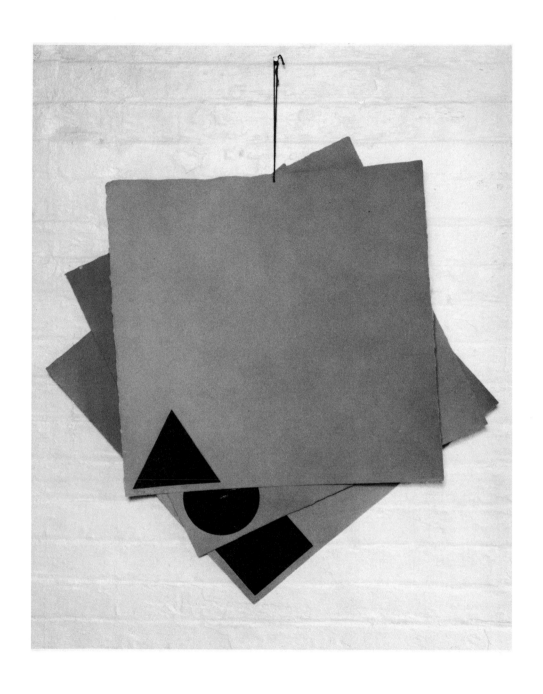

RICHARD SMITH. *Russian I.* 1975.
Etching, 3 sheets, each 20⅛ x 20⅛″ (51.1 x 51.1 cm).

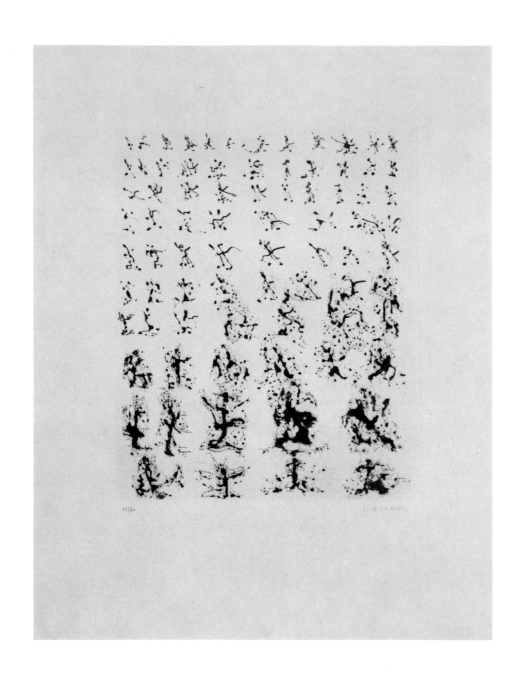

HENRI MICHAUX. Untitled from *Parcours*. 1965.
Etching, 12⅞ x 10⁷⁄₁₆″ (32.8 x 26.5 cm).

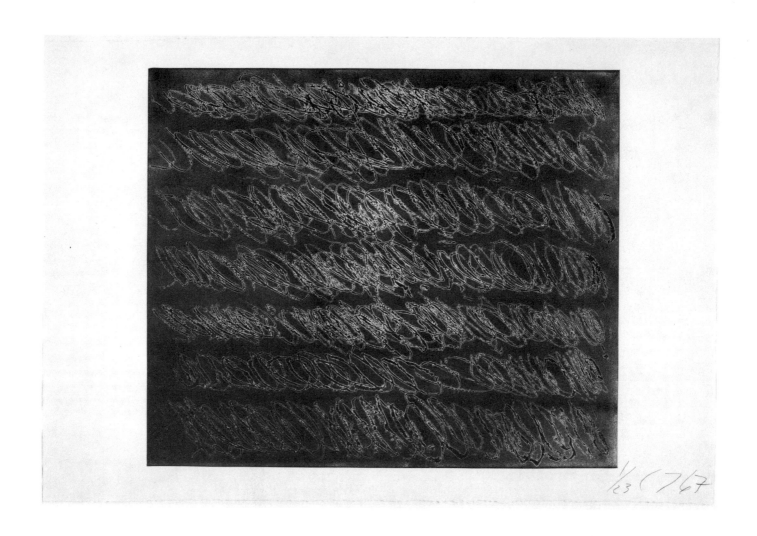

CY TWOMBLY. Untitled II. 1967.
Etching and aquatint,
23⅝ x 28¼″ (60.0 x 71.7 cm).

MANFRED MOHR. *Prog. 148*. 1973.
Computer drawing, 26 x 26″ (66.0 x 66.0 cm).

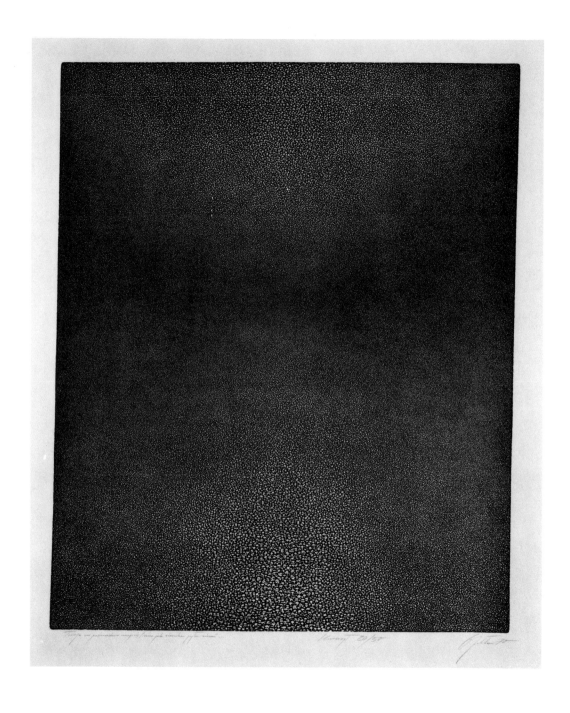

ROMAN OPALKA. *And to that posterity I will grant increase, till it lies like dust on the ground....* 1970. Aquatint, 24⁵⁄₁₆ x 19⁷⁄₁₆″ (61.7 x 49.3 cm).

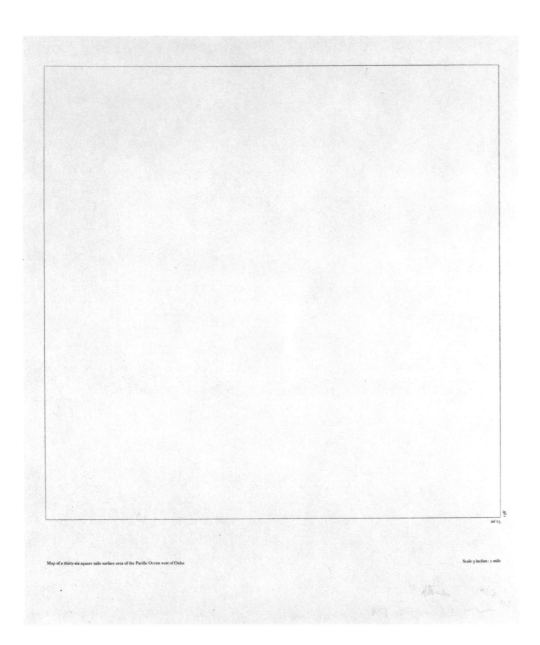

Map of a thirty-six square mile surface area of the Pacific Ocean west of Oahu

Scale 3 inches : 1 mile

TERRY ATKINSON and MICHAEL BALDWIN. *Map of Thirty-six Square Mile Area of Pacific Ocean West of Oahu*. 1967. Letterpress, 19⅞ x 18¼″ (50.5 x 46.4 cm).

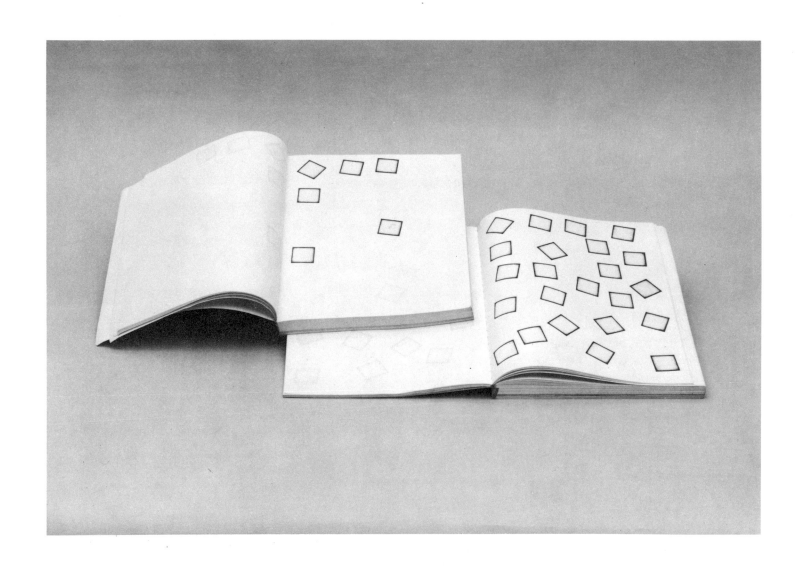

CARL ANDRE. *Xerox Book* by Carl Andre, Robert Barry, Douglas Huebler,
Joseph Kosuth, Sol LeWitt, Robert Morris, Lawrence Weiner.
New York, Siegelaub/Wendler, 1968. Xerox,
10⅞ x 8⅛" (27.6 x 20.6 cm).

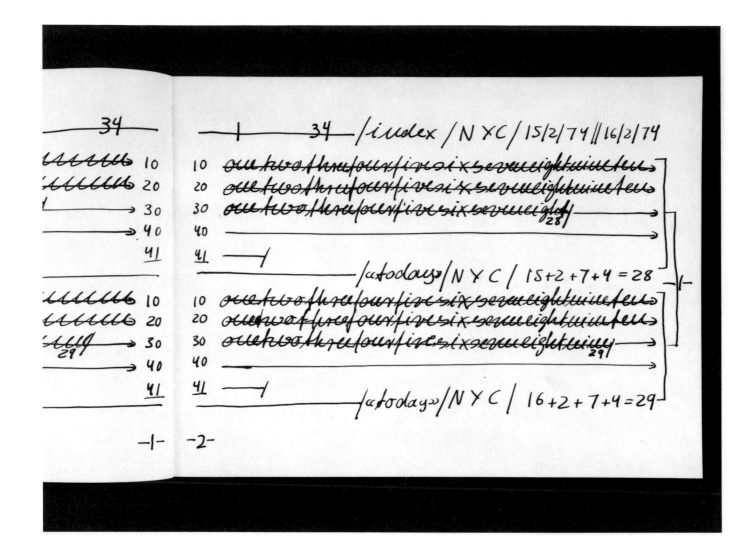

HANNE DARBOVEN. *Diary NYC February 15 Until March 4, 1974.*
New York, Castelli Graphics; Turin, Gran Enzo Sperone; 1974.
Offset, 9 x 12⅛" (22.9 x 30.8 cm).

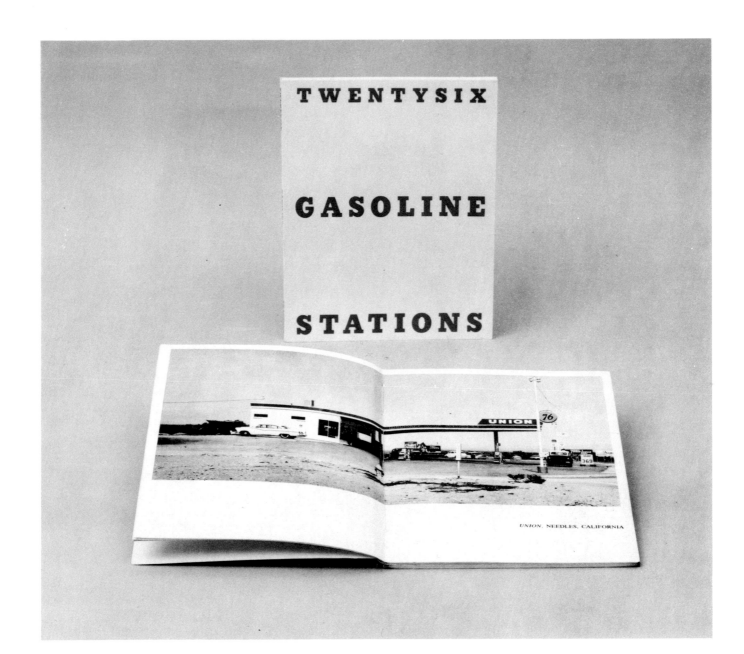

EDWARD RUSCHA. *Twenty-six Gasoline Stations.* 1962.
(Hollywood, National Excelsior Publication, 1963.)
Photo offset, 7⅛ x 5⁹⁄₁₆″ (18.1 x 14.2 cm).

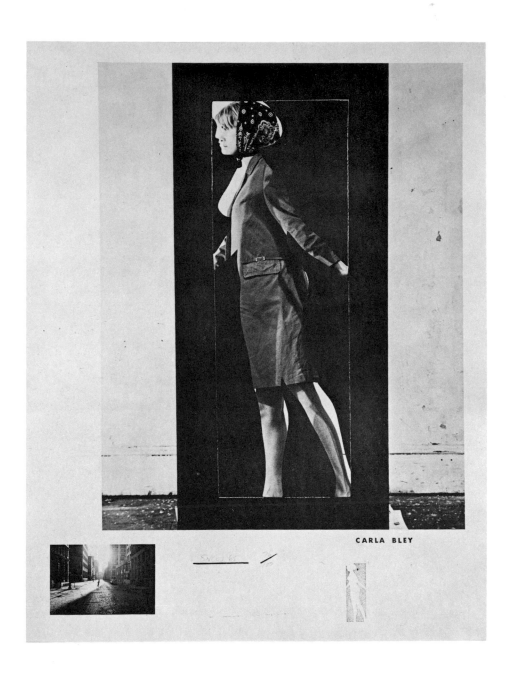

CARLA BLEY

MICHAEL SNOW. *Carla Bley* from *Toronto 20*. 1965.
Photo offset and relief cut,
24⁵⁄₁₆ x 17⁷⁄₈″ (61.7 x 45.4 cm).

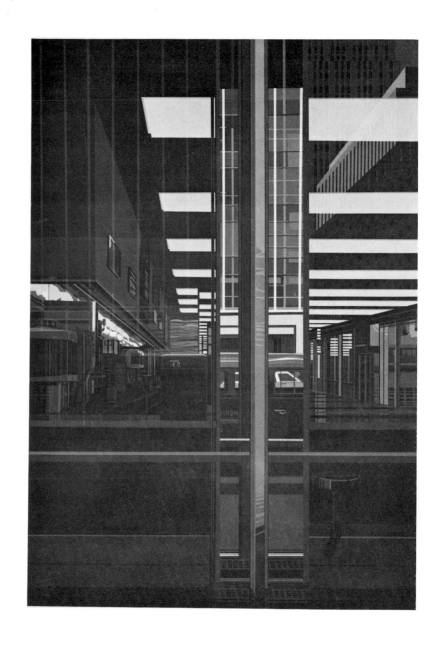

RICHARD ESTES. Plate 5 from *Urban Landscapes No. 2*. 1979.
Silkscreen, 19⅞ x 13⅝₆" (50.4 x 33.8 cm).

Glued forever with despondency to this vista of variations of glooms. Nothing is too dark, dreary, desolate or miserable for us. Our black black years stretch out with pleasantness of morbid memory. The falling of lines our panelled life it is as though we were without a sound, gravity or solid grave. Just flying bat-like into the atmosphere with un-limited appetite. The harsh silver light from other places and corners of our senses makes us blink blindly with horrid realisation of our imagination.

17

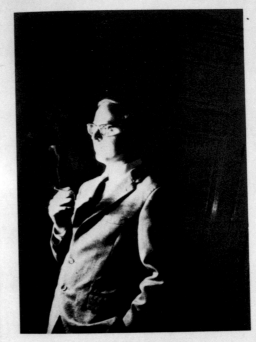

PANELLED LIFE

GILBERT AND GEORGE. *Dark Shadows*. London, Nigel Greenwood, 1976.
Photo offset, 7⅞ x 4¾″ (20.0 x 12.1 cm).

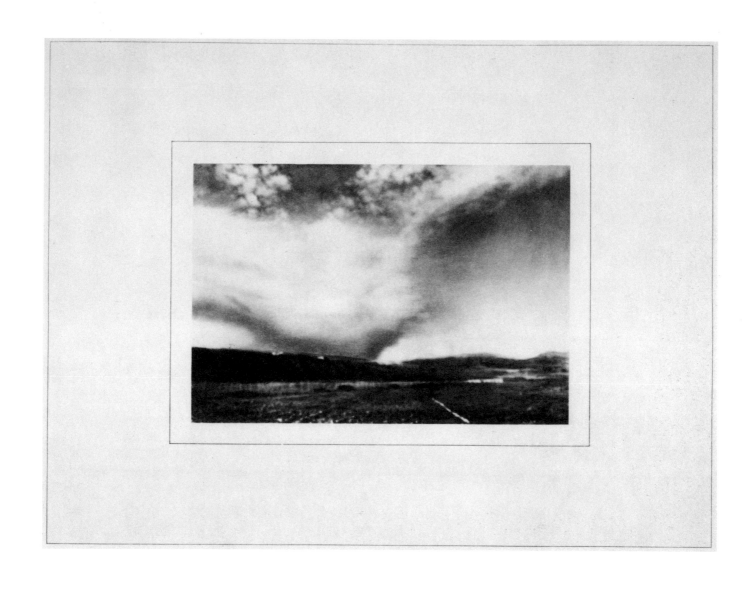

GERHARD RICHTER. Plate 4 from *Canary Islands Landscape*. 1970–71.
Photoengraving with aquatint,
11¹³⁄₁₆ x 15¹³⁄₁₆″ (30.0 x 40.2 cm).

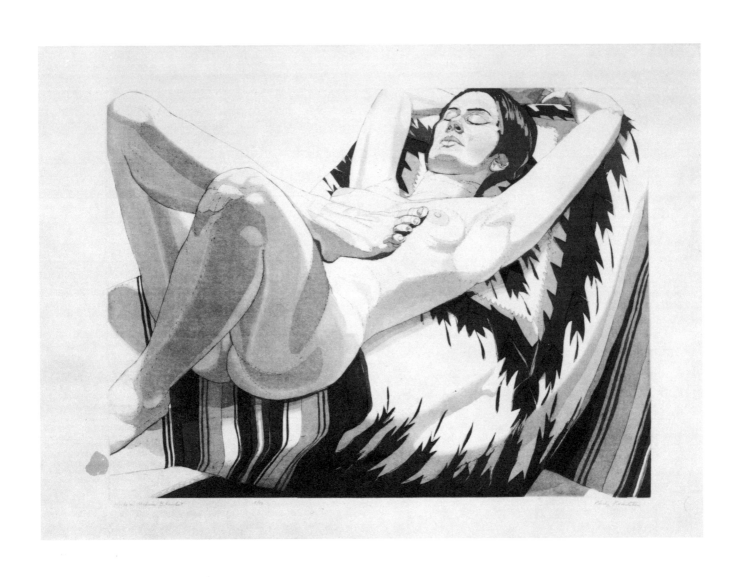

PHILIP PEARLSTEIN. *Nude on Mexican Blanket.* 1971.
Aquatint, 22 x 30″ (55.9 x 76.2 cm).

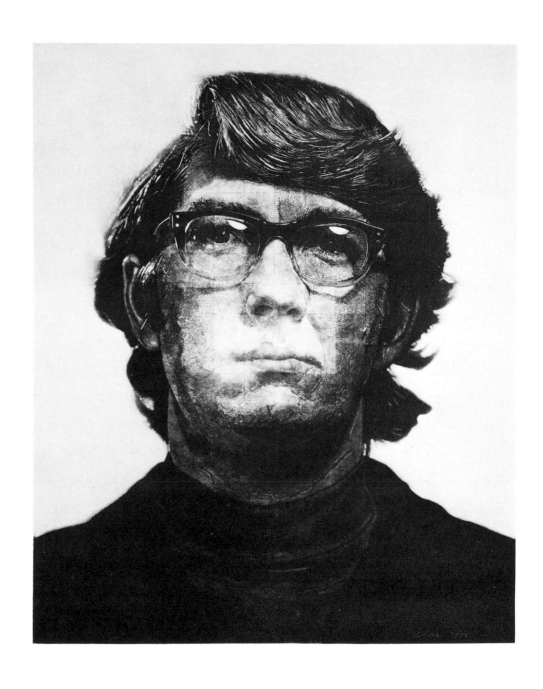

CHUCK CLOSE. *Keith.* 1972.
Mezzotint, 44½ x 34¹⁵⁄₁₆″ (113.0 x 88.7 cm).

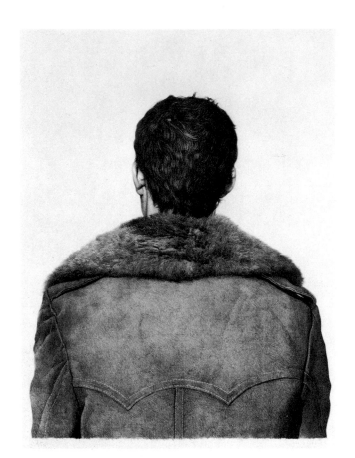
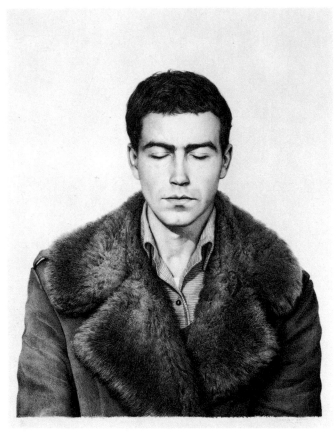

CLAUDIO BRAVO. *Fur Coat Front and Back.* 1976.
Lithograph, 2 sheets together,
22⅜ x 37¹³⁄₁₆″ (56.8 x 96.0 cm).

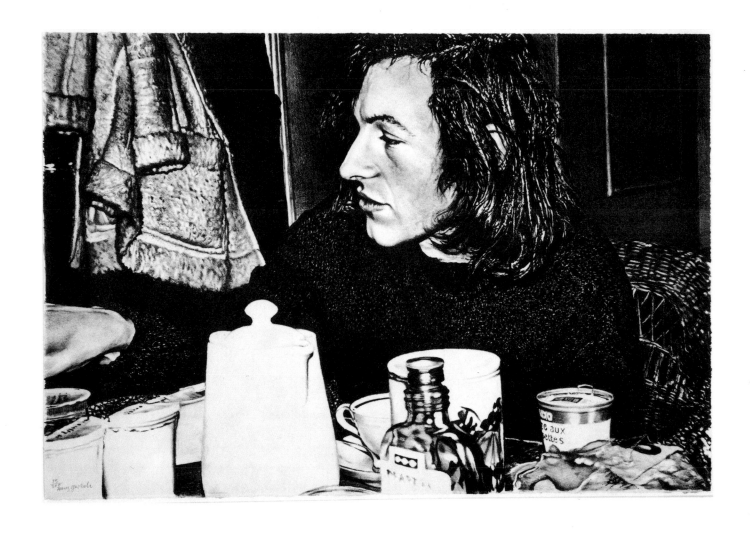

FRANZ GERTSCH. *Jean Frederic Schnyder* from *Documenta: The Super Realists*. 1972.
Lithograph, 23⅜ x 34″ (59.4 x 86.3 cm).

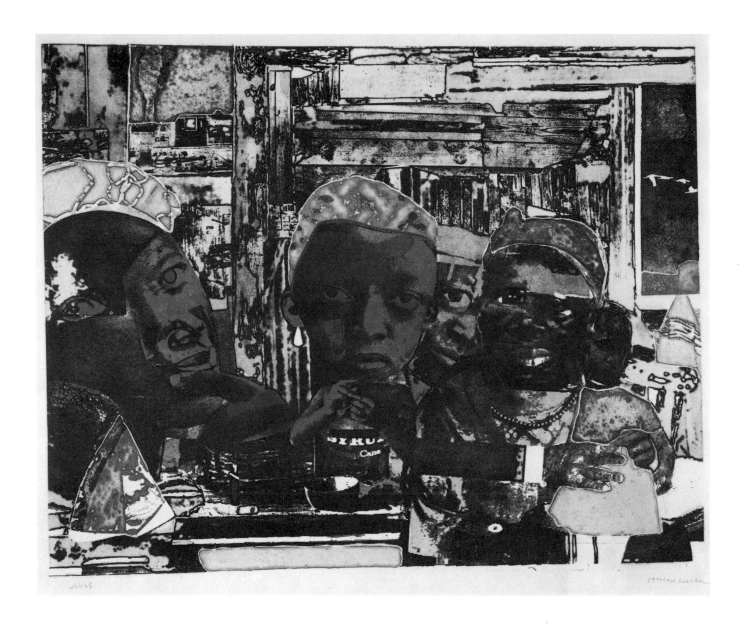

ROMARE BEARDEN. *The Train.* 1975.
Etching, aquatint and stencil, 17¹¹/₁₆ x 22⅛" (44.9 x 56.2 cm).

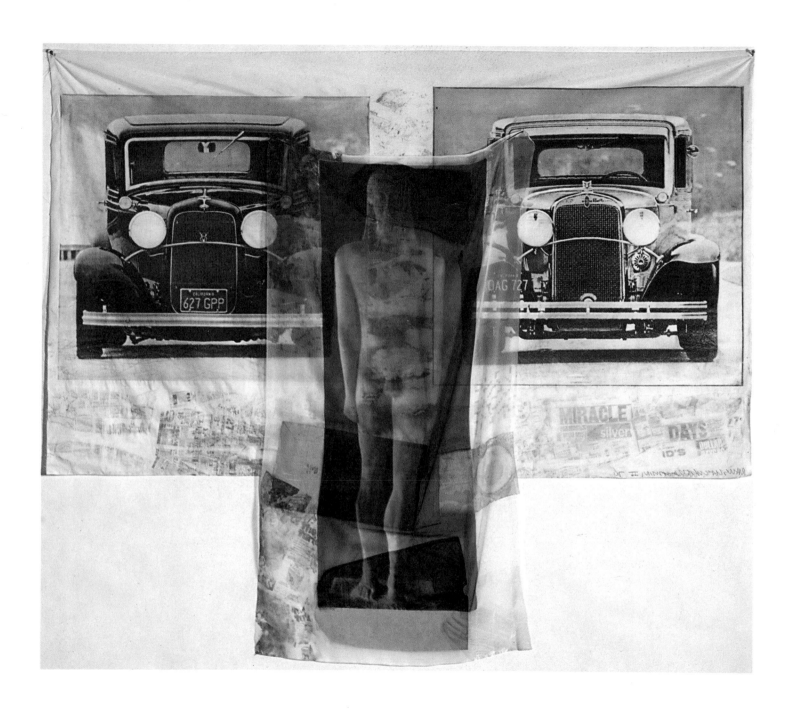

ROBERT RAUSCHENBERG. *Preview* from the *Hoarfrost* series. 1974.
Transfer and collage on cloth,
69 x 80½" (175.2 x 204.4 cm).

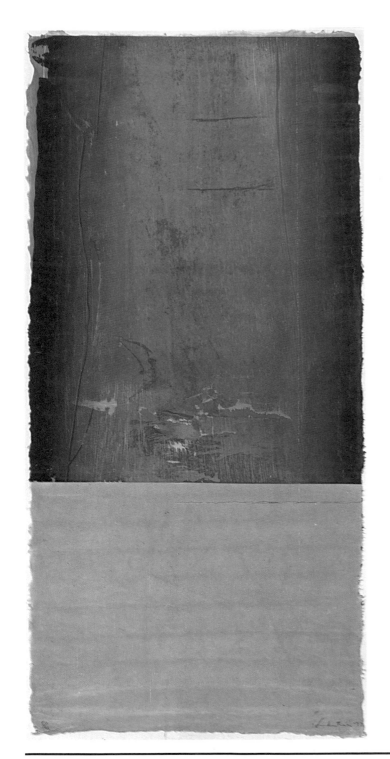

HELEN FRANKENTHALER. *Essence Mulberry.* 1977.
Woodcut. 25 x 18⅞″
(63.5 x 47.9 cm).

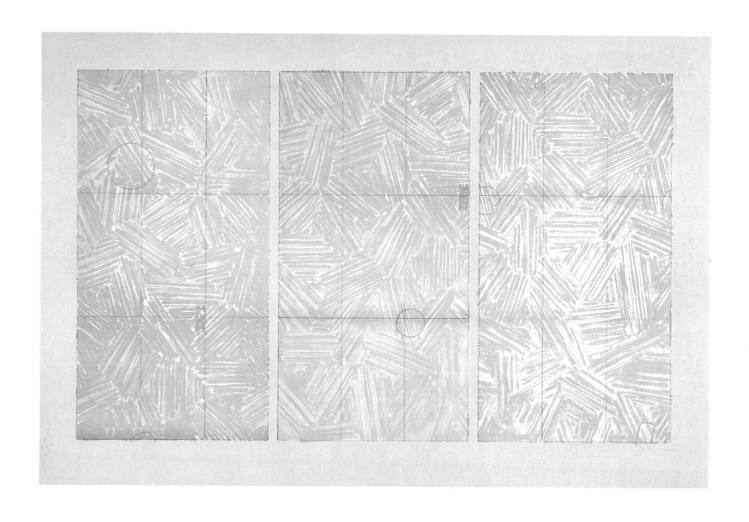

JASPER JOHNS. *Usuyuki.* 1979.
Offset lithograph, 32⅞ x 45¹⁵⁄₁₆″
(83.5 x 116.7 cm).

BLINKY PALERMO (Peter Heisterkamp). *4 Prototypes.* 1970.
Silkscreen, sheets each 23⁹⁄₁₆ x 23⁹⁄₁₆″
(59.8 x 59.8 cm).

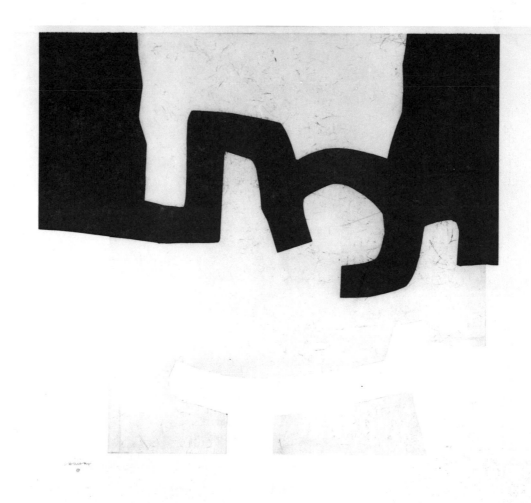

EDUARDO CHILLIDA. *Aundi II.* 1970.
Aquatint, 39½ x 43⅛″ (100.3 x 109.5 cm).

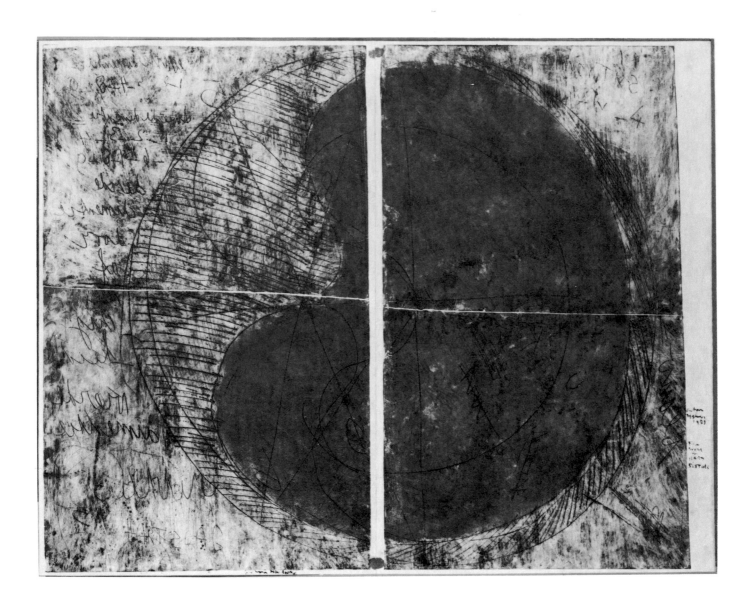

ANTON HEYBOER. *Culture and Heartbeat.* 1962; printed in 1963.
Etching, 2 sheets together,
39¹⁄₁₆ x 49⅛″ (99.2 x 124.7 cm).

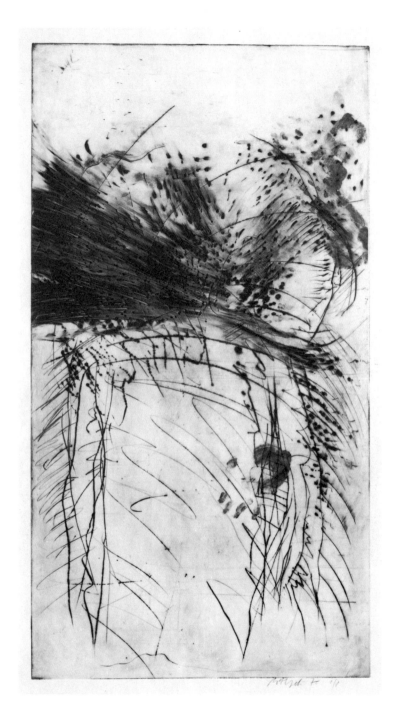

ROLF ISELI. *Mushroom Man I.* 1975.
Drypoint, 59 1/16 x 31 1/4" (150.0 x 79.3 cm).

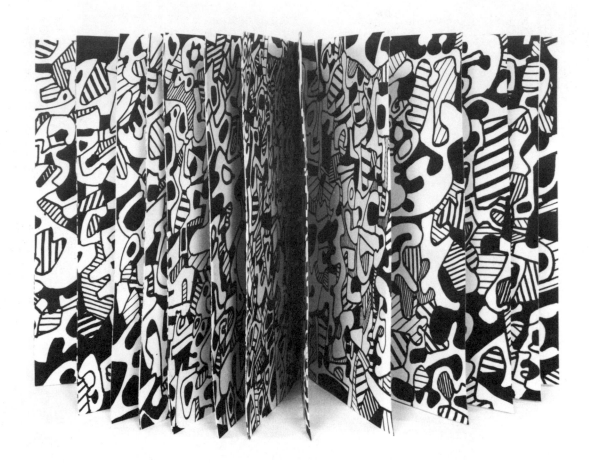

JEAN DUBUFFET. *Parade funèbre pour Charles Estienne.* Paris, Éditions Jeanne Bucher, 1967.
Silkscreen, 10¾ x 8⁹⁄₁₆″ (27.3 x 21.7 cm).

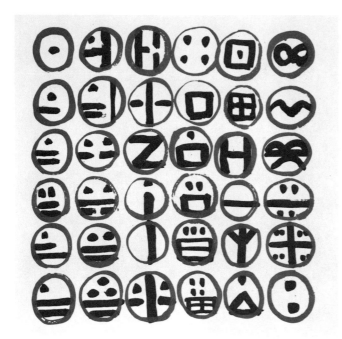 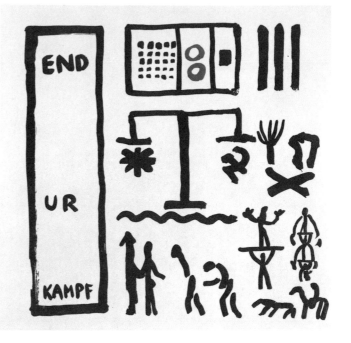

A. R. PENCK. Plates 6 and 9 from *Ur End Standart*. 1972.
Silkscreen, each 24⅞ x 24″ (63.2 x 61.0 cm).

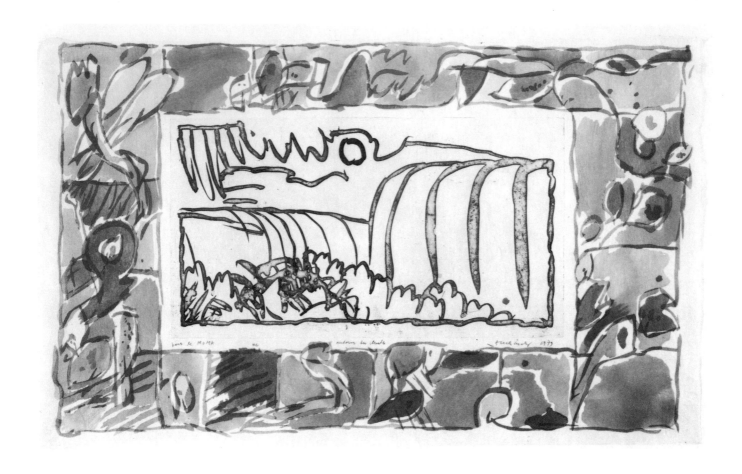

PIERRE ALECHINSKY. *Around the Falls*. 1979.
Hand-colored etching,
22¹⁵⁄₁₆ x 37⅞″ (58.2 x 96.2 cm).

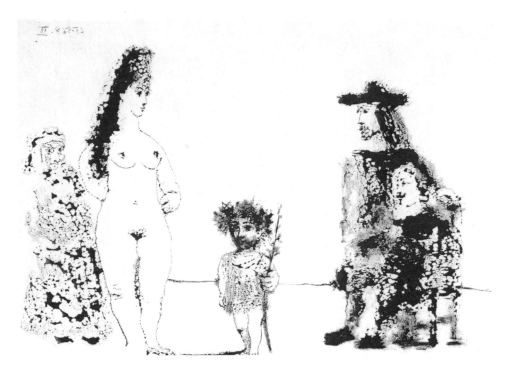

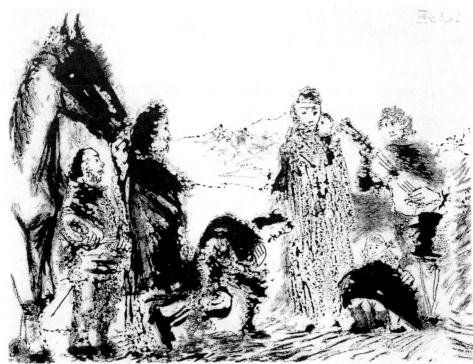

PABLO PICASSO. Plates 111 and 138
from *347 Series*. 1968.
Aquatint, 9¼ x 13″ (23.5 x 33.0 cm)
and 8¾ x 11⅜″ (22.2 x 28.9 cm).

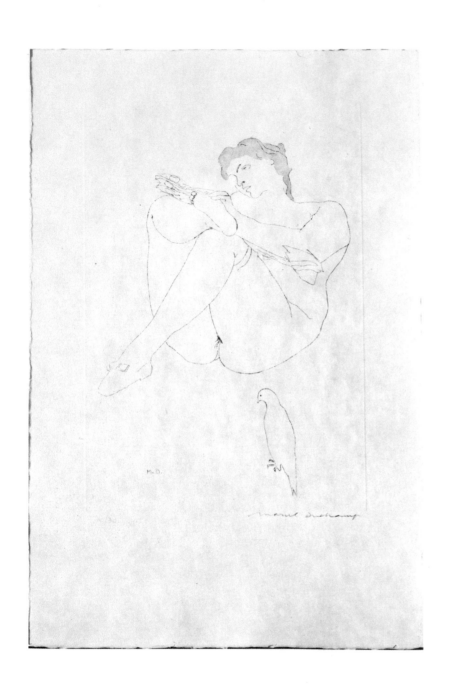

MARCEL DUCHAMP. *Selected Details after Courbet*, State II from
The Large Glass and Related Works (Vol. II) by Arturo Schwarz. Milan, Schwarz Gallery, 1968.
Etching and aquatint, 13¾ x 9⁵⁄₁₆″ (34.9 x 23.7 cm).

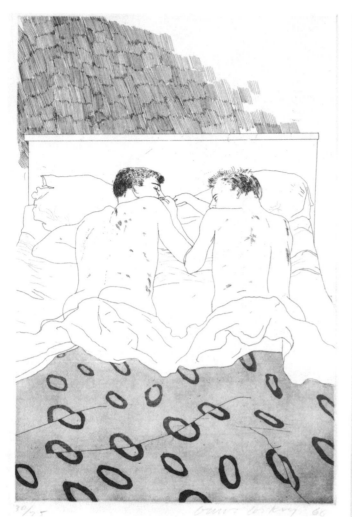

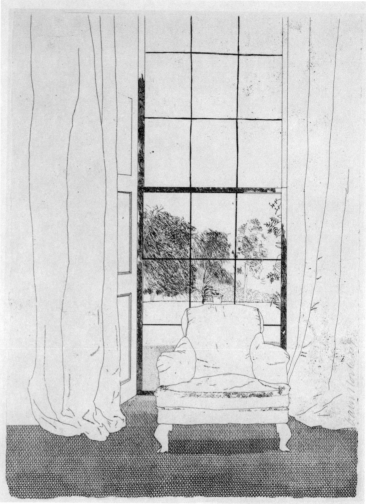

DAVID HOCKNEY. *Two Boys Aged 23 or 24* from
14 Poems from C. P. Cavafy.
London, Petersburg Press, 1966. Etching and aquatint,
13¹³⁄₁₆ x 8¹⁵⁄₁₆" (35.1 x 22.7 cm).

DAVID HOCKNEY. *Home* from *Six Fairy Tales from the Brothers Grimm.*
London, Petersburg Press, 1970.
Etching, 17⁵⁄₁₆ x 12⁵⁄₁₆" (44.0 x 31.3 cm).

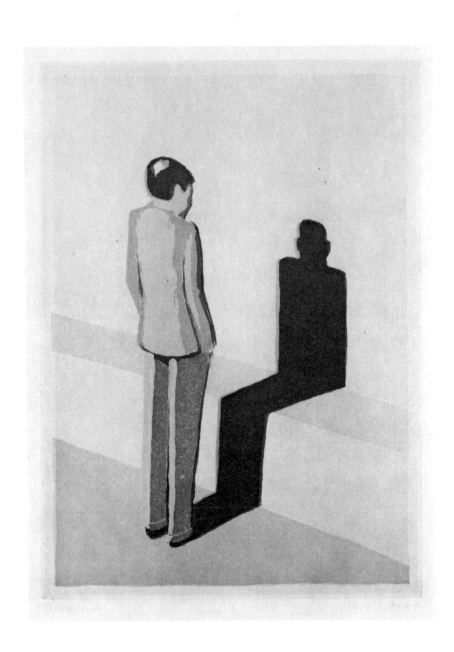

MARKUS RAETZ. Plate from an untitled portfolio. 1977.
Aquatint, 8¼ x 5¾" (21.0 x 14.6 cm).

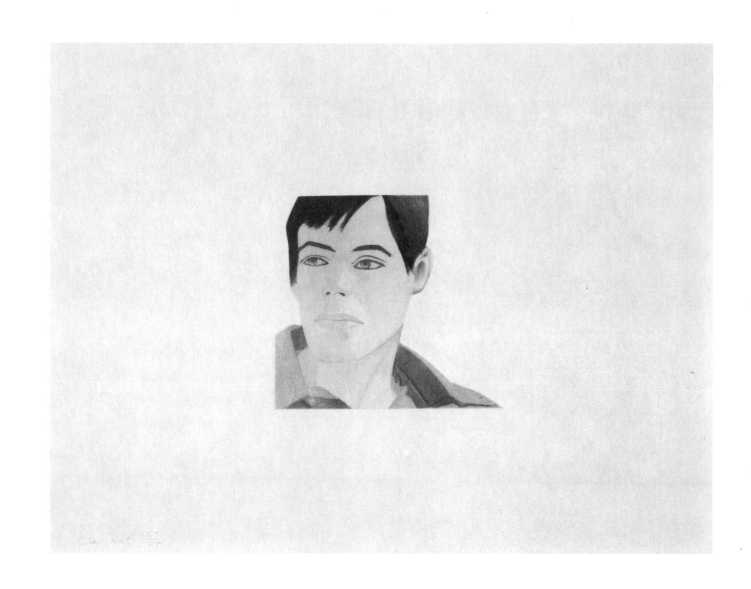

ALEX KATZ. *Carter Ratcliff* from *The Face of the Poet.*
New York, Brooke Alexander and Marlborough Graphics, 1978.
Aquatint, 6 x 6¾″ (15.2 x 17.2 cm).

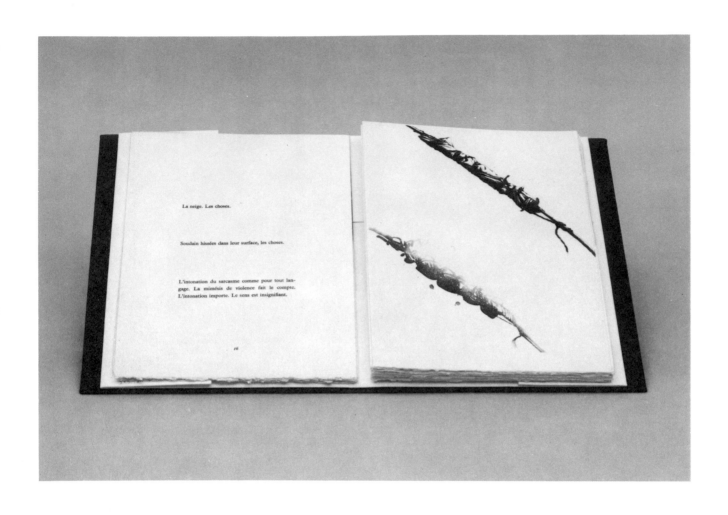

GÉRARD TITUS-CARMEL. Plate 2 from *Sarx* by Pascal Quignard.
Paris, Maeght Éditeur, 1977.
Drypoint and aquatint, 9½ x 7" (24.1 x 17.8 cm).

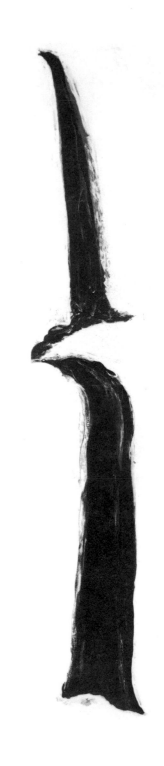

BRYAN HUNT. *Fall with a Bend.* 1979.
Etching and aquatint, 93¹¹/₁₆ x 14⅞" (237.9 x 37.8 cm).

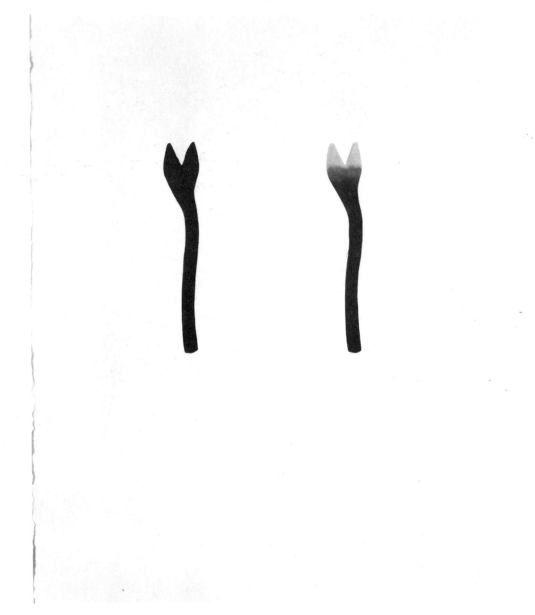

LOIS LANE. Untitled from *Six Aquatints*. 1979.
Aquatint, 23⅞ x 17¹¹⁄₁₆″ (60.6 x 44.9 cm).

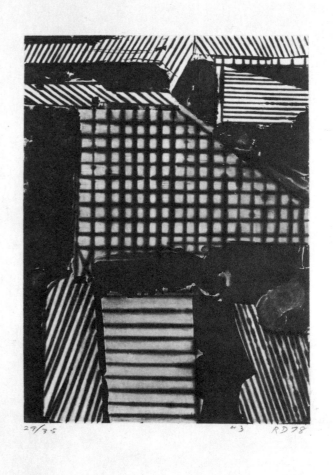

RICHARD DIEBENKORN. Untitled from *5 Aquatints with Drypoint*. 1978.
Aquatint and drypoint,
10^{15}/$_{16}$ x 7^{7}/$_{8}$" (27.8 x 20.0 cm).

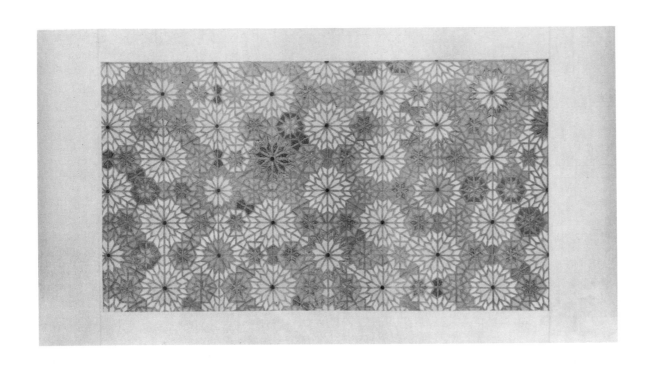

JOYCE KOZLOFF. *Is It Still High Art?* State Ia. 1979.
Lithograph, 17 x 32" (43.2 x 81.3 cm).

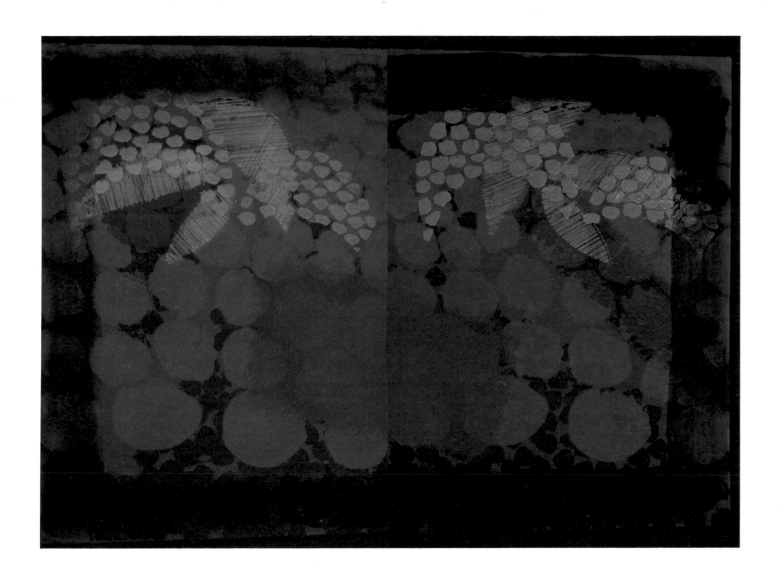

HOWARD HODGKIN. *For B.J.* 1979.
Hand-colored lithograph, 2 sheets together,
41¾ x 59½″ (106.0 x 151.1 cm).

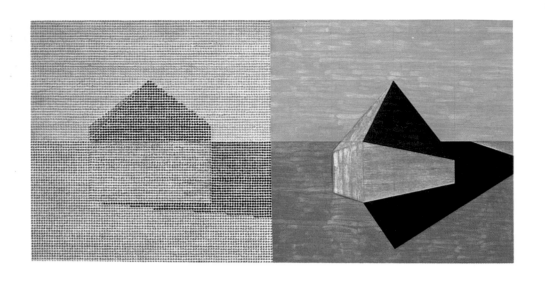

JENNIFER BARTLETT. *Graceland Mansions.* 1979.
Silkscreen, lithograph, etching, drypoint, and woodcut,
5 sheets, each 24 x 24″ (60.9 x 60.9 cm).

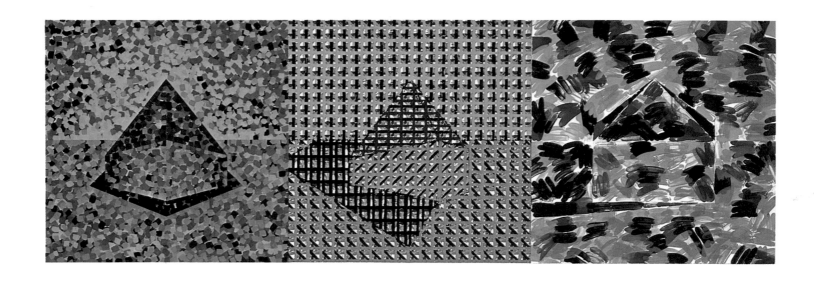

JANNIS KOUNELLIS. Untitled. 1979.
Aquatint and photoetching,
36¹⁵⁄₁₆ x 27⅜″ (93.8 x 69.5 cm).

CATALOG OF THE EXHIBITION

Dates in parentheses do not appear on the works. Unless otherwise noted, measurements are given, height preceding width, as follows: composition size for lithographs, silkscreens, offset media, and woodcuts; plate size for etchings and other intaglio prints; sheet or page size for books, broadsides, and postcards.

Works from the Collections and Library of The Museum of Modern Art are marked with an asterisk (*). Artists' books on deposit from an anonymous collector are marked with a dagger (†).

PRINTS AND PORTFOLIOS

Albers, Josef. American, born Germany, 1888–1976
Four from the portfolio *Homage to the Square*. (1965.) Silkscreen, each 11 x 11" (28.0 x 28.0 cm). Lent by The Metropolitan Museum of Art, gift of Josef Albers, 1970.

Alechinsky, Pierre. Belgian, born 1927
Around the Falls. 1979. Hand-colored etching, 22¹⁵⁄₁₆ x 37⅞" (58.2 x 96.2 cm). Gift of the artist.*

Arakawa, Shusaku. Japanese, born 1936
The Degrees of Meaning. 1973. Silkscreen and lithograph, 27½ x 18⁷⁄₁₆" (69.8 x 46.8 cm). Gift of Frayda and Ronald Feldman.*

Art-Language. See Atkinson, Terry, and Baldwin, Michael.

Artschwager, Richard. American, born 1924
Interior #2. 1977. Drypoint, 9¹⁵⁄₁₆ x 11¹⁵⁄₁₆" (25.2 x 30.3 cm). Janet K. Ruttenberg Fund.*

Asse, Geneviève. French, born 1923
Diagonal. 1974. Drypoint and engraving, 11¾ x 17¹⁵⁄₁₆" (29.8 x 45.5 cm). Lent by the Bibliothèque Nationale, Paris.
Blue Break. 1974. Drypoint, 11¾ x 17¹⁵⁄₁₆" (29.8 x 45.6 cm). Lent by the Bibliothèque Nationale, Paris.

Atkinson, Terry. British, born 1939. And
Baldwin, Michael. British, born 1945
Map of a Thirty-six Square Mile Area of Pacific Ocean West of Oahu. 1967. Letterpress, 19⅞ x 18¼" (50.5 x 46.4 cm). Gift of Donald Karshan.*

Bartlett, Jennifer. American, born 1941
Graceland Mansions. 1979. Silkscreen, lithograph, etching, drypoint, and woodcut on five sheets, each 24 x 24" (60.9 x 60.9 cm). Acquired with matching funds from James R. Epstein and the National Endowment for the Arts.*

Baselitz, Georg. German, born 1938
Eagle. 1977. Linoleum cut, 23⅝ x 10⅝" (60.0 x 27.0 cm). Lent by Galerie Heiner Friedrich, Munich.

Bearden, Romare. American, born 1914
The Train. (1975.) Etching, aquatint, and stencil, 17¹¹⁄₁₆ x 22⅛" (44.9 x 56.2 cm). Purchase.*

Beuys, Joseph. German, born 1921
The Revolution is Us. 1972. Collotype, 75¼ x 40⁹⁄₁₆" (191.0 x 102.0 cm). Lent anonymously.
Minneapolis Fragments. 1977. Six lithographs, each 25³⁄₁₆ x 35" (64.0 x 89.0 cm). Lent by Staatsgalerie Stuttgart, Graphische Sammlung.

Bochner, Mel. American, born 1940
Rules of Inference. 1974. Aquatint, 22¼ x 31¹⁄₁₆" (56.5 x 78.9 cm). John B. Turner Fund.*

Bravo, Claudio. Chilean, born 1936
Fur Coat Front and Back. 1976. Lithograph on two sheets, 22⅜ x 37¹³⁄₁₆" (56.8 x 96.0 cm). Latin American Fund.*

Broodthaers, Marcel. Belgian, 1924–1976
Museum. 1972. Silkscreen on two sheets, 33⅛ x 46⅝" (84.1 x 118.4 cm). Lent by the Stedelijk Museum, Amsterdam.

Bury, Pol. Belgian, born 1922
Circle and Ten Triangles, Yellow-Black. (1976.) Woodcut, 20⁹⁄₁₆ x 22⁹⁄₁₆" (52.2 x 57.3 cm). Abby Aldrich Rockefeller Fund.*

Canogar, Rafael. Spanish, born 1935
Your Screams Will be Heard from the series *The Earth*. 1969. Lithograph, 22¼ x 30¼" (56.5 x 76.8 cm). Gift of Kleiner, Bell and Co.*

Caulfield, Patrick. British, born 1936
Sweet Bowl. 1967. Silkscreen, 22 x 36" (55.9 x 91.4 cm). Lent by the Trustees of the Tate Gallery.

Chillida, Eduardo. Spanish, born 1924
Aundi II. (1970.) Aquatint, 39½ x 43⅛" (100.3 x 109.5 cm). Lent by the Stedelijk Museum, Amsterdam.

Christo (Javacheff). American, born Bulgaria 1935
MOMA (rear) from the portfolio *(Some) Not Realized Projects*. 1971. Lithograph and

collage, 27¹⁵⁄₁₆ x 22″ (71.0 x 55.9 cm). Larry Aldrich and Walter Bareiss Funds.*

Claus, Carlfriedrich. East German, born 1930
Psychological Improvisation I: Struggle. 1972. Lithograph, printed on recto and verso, 16¹³⁄₁₆ x 13⅛″ (42.7 x 33.4 cm). Gift of Staatliche Kunstsammlungen Dresden.*
Psychological Improvisation II: Encounter. 1972. Lithograph, printed on recto and verso, 15¹³⁄₁₆ x 13¹⁄₁₆″. (40.2 x 33.2 cm). Gift of Staatliche Kunstsammlungen Dresden.*

Close, Chuck. American, born 1940
Keith. 1972. Mezzotint, 44½ x 34¹⁵⁄₁₆″ (113.0 x 88.7 cm). Lent by William R. Acquavella.

D'Arcangelo, Allan. American, born 1930
June Moon from the portfolio *69.* 1969. Silkscreen, 23½ x 25⁹⁄₁₆″ (59.7 x 64.9 cm). Gift of the artist.*

Diebenkorn, Richard. American, born 1922
Two from the portfolio *5 Aquatints with Drypoint.* 1978. Aquatint and drypoint, each 10¹⁵⁄₁₆ x 7⅞″ (27.8 x 20.0 cm). John B. Turner Fund.*

Dine, Jim. American, born 1935
Eleven Part Self Portrait (Red Pony). 1965. Lithograph, 39¾ x 29⅝″ (101.0 x 75.2 cm). Gift of The Celeste and Armand Bartos Foundation.*
Drag. 1967. Etching, aquatint, and stencil, 31¼ x 47″ (79.3 x 119.3 cm). Gift of Mr. and Mrs. John Jakobson.*
The Die-Maker from the series *Eight Sheets from an Undefined Novel.* 1976. Hand-colored etching and aquatint, 23¹¹⁄₁₆ x 19¹³⁄₁₆″ (60.2 x 50.3 cm). Gift of Nelson Blitz, Jr., through The Associates of the Department of Prints and Illustrated Books.*

Erró, Gudmundur. French, born Iceland 1932
Untitled from the portfolio *Made in Japan.* 1972. Lithograph, 17⅛ x 14⅛″ (43.5 x 35.9 cm). Lent by the Bibliothèque Nationale, Paris.

Estes, Richard. American, born 1936
Untitled from the portfolio *Urban Landscapes No. 2.* 1979. Silkscreen, 19⅞ x 13⁵⁄₁₆″ (50.4 x 33.8 cm). Gift of a friend, in memory of Beth Lisa Feldman and Wallace Reiss.*

Fahlström, Oyvind. Swedish, born Brazil, 1928–1976
Eddy (Sylvie's Brother) in the Desert from the portfolio *New York International.* 1966. Silkscreen, 17¹⁄₁₆ x 21¹³⁄₁₆″ (43.4 x 55.4 cm). Gift of Tanglewood Press.*

Filliou, Robert. French, born 1926
Untitled from the portfolio *7 Childlike Uses of Warlike Material.* 1971. Silkscreen, 19⁷⁄₁₆ x 27⅜″

(49.4 x 69.5 cm). Lent by the Bibliothèque Nationale, Paris.

Fontana, Lucio. Italian, 1899–1968
Untitled from the portfolio *Six Original Etchings.* 1964. Etching and embossing, 13¾ x 16¾″ (34.9 x 42.5 cm). Abby Aldrich Rockefeller Fund.*

Frankenthaler, Helen. American, born 1928
Essence Mulberry. 1977. Woodcut, 25 x 18⅞″ (63.5 x 47.9 cm). John B. Turner Fund.*

Gertsch, Franz. Swiss, born 1930
Jean Frederic Schnyder from the portfolio *Documenta: The Super Realists.* (1972.) Lithograph, 23⅜ x 34″ (59.4 x 86.3 cm). Gift of Dr. Samuel Mandel.*

Graubner, Gotthard. German, born 1930
Two from the portfolio *6 Aquatints.* 1976. Aquatint, each sheet 24⁷⁄₁₆ x 18½″ (62.0 x 47.0 cm). Lent by Verlag Schellmann & Klüser, Munich.

Green, Alan. British, born 1932
Center to Edge—Neutral to Black. 1979. Etching, 18⅞ x 18¹³⁄₁₆″ (47.9 x 47.7 cm). Gift of Annely Juda, in honor of William S. Lieberman.*

Hamilton, Richard. British, born 1922
Interior. 1964. Silkscreen, 19⁵⁄₁₆ x 25⅛″ (49.1 x 63.8 cm). Gift of Mrs. Joseph M. Edinburg.*
Kent State. (1970.) Silkscreen, 26⁷⁄₁₆ x 34⅜″ (67.1 x 87.3 cm). John R. Jakobson Foundation Fund.*

Heindorff, Michael. German, born 1949
For S.C. II. (1978.) Drypoint, 6¹³⁄₁₆ x 10⅝″ (17.3 x 27.0 cm). John R. Jakobson Foundation Fund.*

Heizer, Michael. American, born 1944
Circle III. 1977. Etching, aquatint, and roulette, 26½ x 24¹⁵⁄₁₆″ (67.3 x 63.3 cm). John B. Turner Fund.*

Heyboer, Anton. Dutch, born 1924
Culture and Heartbeat. (1962, dated 1963.) Etching, 39¹⁄₁₆ x 49⅛″ (99.2 x 124.7 cm). John S. Newberry Fund.*

Hockney, David. British, born 1937
Two Boys Aged 23 or 24 from the portfolio *14 Poems from C. P. Cavafy.* 1966. Etching and aquatint, 13¹³⁄₁₆ x 8¹⁵⁄₁₆″ (35.1 x 22.7 cm). Celeste and Armand Bartos Foundation Fund.*
Panama Hat from the portfolio *Prints for Phoenix House.* 1972. Etching and aquatint, 14⁵⁄₁₆ x 13⅜″ (36.4 x 34.0 cm). Gift of Brooke and Carolyn Alexander.*

Hodgkin, Howard. British, born 1932
For B.J. 1979. Hand-colored lithograph on two sheets, 41¾ x 59½″ (106.0 x 151.1 cm). Lent by Bernard Jacobson Ltd.

Holstein, Pieter. Dutch, born 1937
Nothing Doing (5). (1969.) Hand-colored etching, 9⁹⁄₁₆ x 10³⁄₁₆″ (24.2 x 25.8 cm). Gift of Mr. and Mrs. Wolfgang Schoenborn.*

Hunt, Bryan. American, born 1947
Fall with a Bend. 1979. Etching and aquatint, 83¾ x 14¾″ (212.6 x 37.4 cm). Acquired with matching funds from Mrs. Gertrud A. Mellon and the National Endowment for the Arts.*

Ida, Shoichi. Japanese, born 1941
Paper Between Two Stones and Rock from the series *The Surface Is The Between.* 1977. Offset lithograph and embossing, 37 x 23½″ (94.0 x 59.7 cm). Mrs. John D. Rockefeller 3rd Fund.*

Indiana, Robert. American, born 1928
Love. 1967. Silkscreen, 36 x 36″ (91.4 x 91.4 cm). Lent by Sara F. Katz Howell, New Jersey.

Iseli, Rolf. Swiss, born 1934
Mushroom Man I. 1975. Drypoint, 59¹⁄₁₆ x 31¼″ (150.0 x 79.3 cm). Lent by the Stedelijk Museum, Amsterdam.

Jacquet, Alain. French, born 1939
Portrait. 1964. Silkscreen on canvas, 64 x 54″ (162.5 x 137.1 cm). Lent by Armand P. Arman.

Jensen, Alfred. American, born Guatemala 1903
Untitled from the portfolio *A Pythagorean Notebook.* (1965.) Lithograph, 22⅝ x 16½″ (57.4 x 41.9 cm). Gift of Kleiner, Bell & Co.*

Johns, Jasper. American, born 1930
Figure 7 from the series *Colored Numerals.* 1969. Lithograph, 28⅛ x 22⅜″ (71.4 x 56.9 cm). Gift of Gemini G.E.L.*
Scent. 1975–76. Lithograph, linoleum cut, woodcut, and embossing, 28½ x 44⅜″ (72.4 x 112.7 cm). Gift of Celeste Bartos.*
The Dutch Wives. 1978. Silkscreen, 40¹¹⁄₁₆ x 51¼″ (103.3 x 130.1 cm). Lent by Mr. and Mrs. Harry Kahn.
Usuyuki. 1979. Offset lithograph, 32⅞ x 45¹⁵⁄₁₆″ (83.5 x 116.7 cm). Gift of Celeste Bartos.*

Judd, Donald. American, born 1928
6-L. 1961–69. Woodcut, 25⅝ x 15¹⁵⁄₁₆″ (65.1 x 40.5 cm). Gift of Philip Johnson.*
11-L. 1961–69. Woodcut, 26³⁄₁₆ x 16″ (66.5 x 40.6 cm). Gift of Philip Johnson.*

Kawara, On. Japanese, born 1933
I Am Still Alive. October 14, 17, and 22, 1970. Three telegrams: 4¾ x 7⅜″ (12.0 x 18.8 cm); 5¹³⁄₁₆ x 8⁷⁄₁₆″ (14.7 x 21.4 cm); 4¾ x 8⁷⁄₁₆″ (12.0 x 21.4 cm). Lent by the Victoria and Albert Museum, London.

Kelly, Ellsworth. American, born 1923
Germigny from the *Third Curve Series.* (1976.) Lithograph, intaglio, and debossing, 22 x 29″ (55.9 x 73.7 cm). Gift of Mr. and Mrs. John G. Powers.*
Senanque from the *Third Curve Series.* (1976.) Lithograph, intaglio, and debossing, 22 x 29″ (55.9 x 73.7 cm). Gift of Mr. and Mrs. Peter A. Rübel (by exchange).*

Kitaj, Ronald B. American, born 1932
In Our Time Covers for a Small Library after the Life for the Most Part. (1969.) Portfolio of 50 silkscreens, each sheet 22 x 30″ (55.8 x 76.2 cm). John B. Turner Fund.*

Kosuth, Joseph. American, born 1945
Art Made with a Rubber Stamp. (1965.) Rubber stamp, sheet 11½ x 14¾″ (29.2 x 37.5 cm). Lent by Armand P. Arman.

Kounellis, Jannis. Greek, born 1936
Untitled. (1979.) Photoetching and aquatint, 36¹⁵⁄₁₆ x 27⅜″ (93.8 x 69.5 cm). Mrs. John D. Rockefeller 3rd Fund.*

Kozloff, Joyce. American, born 1942
Is It Still High Art? (State I A). 1979. Lithograph on silk, 17 x 32″ (43.2 x 81.3 cm). Lent by Barbara Gladstone Gallery.

Lane, Lois. American, born 1948
Untitled from the portfolio *Six Aquatints.* 1979. Aquatint, 23⅞ x 17¹¹⁄₁₆″ (60.6 x 44.9 cm). John B. Turner Fund.*

Levine, Les. Canadian, born Ireland 1935
Conceptual Decorative. 1970. Silkscreen, 33⅛ x 41¹⁵⁄₁₆″ (84.1 x 106.5 cm). John B. Turner Fund.*

LeWitt, Sol. American, born 1928
Lines from Sides, Corners and Center. (1977.) Etching and aquatint, 34⅝x 34⅞″ (87.9 x 88.5 cm). Lent anonymously.

Lichtenstein, Roy. American, born 1923
Reverie from the portfolio *11 Pop Artists* (Vol. II). (1965.) Silkscreen, 27⅛ x 22¹⁵⁄₁₆″ (68.9 x 58.2 cm). Gift of Original Editions.*
Peace through Chemistry I. 1970. Lithograph and silkscreen, 38 x 64″ (96.5 x 162.5 cm). Lent by the Richard Brown Baker Collection.

Luginbühl, Bernhard. Swiss, born 1929
Plan for Cyclops. 1967–70. Engraving, 30¾ x 39″ (78.2 x 99.0 cm). Lent by the Stedelijk Museum, Amsterdam.

Mack, Heinz. German, born 1931
Untitled from the portfolio *made in silver.* 1966. Silkscreen, 16⅝ x 25⅛″ (42.3 x 63.9 cm). Celeste and Armand P. Bartos Fund.*

Marden, Brice. American, born 1938
Untitled from the portfolio *Ten Days.* 1971. Etching, 12 x 15¹⁄₁₆″ (30.5 x 38.2 cm). John B. Turner Fund.*

Michaux, Henri. French, born Belgium 1899

Two from the portfolio *Voyages*. (1965.) Etching, each 12⅞ x 10⁷⁄₁₆" (32.8 x 26.5 cm). Mrs. John D. Rockefeller 3rd Fund.*

Miró, Joan. Spanish, born 1893
The Large Carnivore. (1969.) Etching, aquatint, and carborundum, 36¼ x 23¹⁄₁₆" (92.0 x 58.5 cm). Lent by Galerie Maeght, New York Office.

Mohr, Manfred. German, born 1938
Prog. 148. 1973. Computer drawing, 26 x 26" (66.0 x 66.0 cm). Lent by the Staatsgalerie Stuttgart, Graphische Sammlung.

Morellet, François. French, born 1926
Two from the portfolio *40,000 Squares*. (1971.) Silkscreen, each 31½ x 31½" (80.0 x 80.0 cm). Lent by the Bibliothèque Nationale, Paris.

Morris, Robert. American, born 1931
Steam from the portfolio *Earth Projects*. 1969. Lithograph, 20 x 27¹⁵⁄₁₆" (50.8 x 71.0 cm). John B. Turner Fund.*

Nauman, Bruce. American, born 1941
Untitled from the series *Studies for Holograms*. 1970. Silkscreen, 20⅜ x 26" (51.7 x 66.0 cm). John B. Turner Fund.*

Newman, Barnett. American, 1905–1970
Untitled etching #2. 1969. Etching and aquatint, 23⅜ x 14¹¹⁄₁₆" (59.4 x 37.3 cm). Gift of The Celeste and Armand Bartos Foundation.*

Noda, Tetsuya. Japanese, born 1940
Diary: April 22, '70 in New York. 1970. Silkscreen and woodcut, 9⅜ x 9⅜" (23.8 x 23.8 cm). Gift of Mr. and Mrs. Wolfgang Schoenborn.*

Oldenburg, Claes. American, born Sweden 1929
Teabag from the series *Four on Plexiglas*. (1966.) Silkscreen on felt, clear plexiglas and plastic, 39⁵⁄₁₆ x 28¹⁄₁₆ x 3" (99.8 x 71.3 x 7.6 cm). Gift of Lester Avnet.*

Opalka, Roman. Polish, born France 1931
and to that posterity I will grant increase, till it lies like dust on the ground... 1970. Aquatint, 24⁵⁄₁₆ x 19⁷⁄₁₆" (61.7 x 49.3 cm). Janet K. Ruttenberg Fund.*

Palermo, Blinky (Peter Heisterkamp). German, 1943–1977
4 Prototypes. 1970. Portfolio of four silkscreens, each sheet 23⁹⁄₁₆ x 23⁹⁄₁₆" (59.8 x 59.8 cm). Gift of Cosmopolitan Arts Foundation.*

Paolozzi, Eduardo. British, born 1924
Wittgenstein in New York from the portfolio *As Is When*. 1965. Silkscreen, 30 x 21⅛" (76.2 x 53.6 cm). Joseph G. Mayer Foundation Fund.*
Moonstrips Empire News. 1967. Portfolio of 100 silkscreens, each sheet 15 x 10" (38.0 x 25.4 cm). Gift of the artist.*

Pearlstein, Philip. American, born 1924
Nude on Mexican Blanket. 1971. Aquatint, 22 x 30" (55.9 x 76.2 cm). Lent by the Richard Brown Baker Collection.

Penck, A. R. (Ralf Winkler). East German, born 1939
Plates I, VI, VII, IX, XIV, and XV from the portfolio *Ur End Standart*. 1972. Silkscreen, each sheet 27⁹⁄₁₆ x 27⁹⁄₁₆" (70.0 x 70.0 cm). Mrs. Gilbert W. Chapman Fund.*

Phillips, Tom. British, born 1937
The Birth of Art. 1973. Series of 10 etchings, each 11 x 22⁷⁄₁₆" (28.0 x 57.0 cm). Lent by the Trustees of the Tate Gallery.

Picasso, Pablo. Spanish, 1881–1973
Plates 111, 114, 138, and 235 from the *347 Series*. 1968. Aquatint, 111 and 114: each 9¼ x 13" (23.5 x 33.0 cm); 138: 8¾ x 11⅜" (22.2 x 28.9 cm); 235: 6⅞ x 10¼" (17.5 x 26.0 cm). Lent by Reiss-Cohen, Inc.

Picelj, Ivan. Yugoslavian, born 1924
CM & B-32. (c. 1969.) Silkscreen, 25¹¹⁄₁₆ x 25⁹⁄₁₆" (65.3 x 64.9 cm). Lent by Joan Kaplan, Joan Kaplan Fine Art.

Pistoletto, Michelangelo. Italian, born 1933
Turkish Bath. 1971. Silkscreen on stainless steel, 27¼ x 40" (69.2 x 101.6 cm). Lent by Sidney Janis Gallery Editions.

Raetz, Markus. Swiss, born 1941
Two from an untitled portfolio. 1977. Etching and aquatint, each 8¼ x 5¾" (21.0 x 14.6 cm). Lent by Galerie Stähli, Zurich.

Rainer, Arnulf. Austrian, born 1929
Self-Portrait. (c. 1975.) Photogravure, etching, and drypoint, 11¹⁄₁₆ x 12½" (28.0 x 31.7 cm). Larry Aldrich Fund.*

Rauschenberg, Robert. American, born 1925
Signs. 1970. Silkscreen, 43 x 34" (109.2 x 86.3 cm). Lent by Elizabeth Mize, Chelsea, Vermont.
Preview from the *Hoarfrost* series. 1974. Transfer and collage on cloth, 69 x 80½" (175.2 x 204.4 cm). Purchase.*

Raysse, Martial. French, born 1936
Beautiful Concentrated Summer. 1967. Silkscreen on felt, plastic, and parchment with neon, 75 x 19½" (193.0 x 49.5 cm). Lent by Sergio Tosi Stampatore.

Reinhardt, Ad. American, 1913–1967
Two from the portfolio *10 Screenprints by Ad Reinhardt*. (1966.) Silkscreen, each 18 x 9" (45.7 x 22.9 cm). John B. Turner Fund.*
Untitled from the portfolio *Artists and Writers Protest Against the War in Vietnam*. (1967.)

Silkscreen and collage, 11¼ x 3¼" (28.6 x 8.3 cm). John B. Turner Fund.*

Richter, Gerhard. German, born 1932
Plate 4 from the portfolio *Canary Islands Landscape.* (1970–71.) Photoengraving and aquatint, 11¹³⁄₁₆ x 15¹³⁄₁₆" (30.0 x 40.2 cm). Gift of Carol O. Selle.*

Riley, Bridget. British, born 1931
Print A from the series *19 Greys.* 1968. Silkscreen, 30 x 30" (76.2 x 76.2 cm). Lent by the Trustees of the Tate Gallery.

Rosenquist, James. American, born 1933
Horse Blinders (East). 1972. Silkscreen, lithograph, and collage, 36¼ x 67½" (92.0 x 171.4 cm). Lent by the Richard Brown Baker Collection.

Roth, Dieter. Swiss, born Germany 1930
6 Piccadillies. 1970. Series of six lithographs and silkscreens, each 19¹¹⁄₁₆ x 27⁹⁄₁₆" (50.0 x 70.0 cm). Lent by Petersburg Press.

Ruscha, Edward. American, born 1937
Standard Station. 1966. Silkscreen, 19½ x 36¹⁵⁄₁₆" (49.5 x 93.8 cm). John B. Turner Fund.*

Ryman, Robert. American, born 1930
Two from the series *6 Aquatints.* 1975. Aquatint, 35½ x 35½" (90.2 x 90.2 cm); 35¾ x 35¾" (90.8 x 90.8 cm). Lent by Parasol Press Ltd.

Smith, Richard. British, born 1931
Russian I. 1975. Etching on three sheets, each 20⅛ x 20⅛" (51.1 x 51.1 cm). Lent by Bernard Jacobson Ltd.

Snow, Michael. Canadian, born 1928
Carla Bley from the portfolio *Toronto 20.* 1965. Photo-offset and relief cut, 24⁵⁄₁₆ x 17⅞" (61.7 x 45.4 cm). Gift of Mrs. Samuel Bronfman, Mrs. John David Eaton, and Mr. Samuel J. Zacks (through the International Council).*

Soto, Jesús Rafael. Venezuelan, born 1923
Untitled B. (1971.) Embossed silkscreen, 26⅞ x 26⅞" (68.2 x 68.2 cm). Latin American Fund.*

Sovák, Pravoslav. Czechoslovakian, born 1926
...you are wellcome... from the portfolio *indirect messages.* 1972. Etching and aquatint, 12¹¹⁄₁₆ x 13⁷⁄₁₆" (32.3 x 34.1 cm). Gift of Messrs. John Clancy and Peter Ornstein.*

Stella, Frank. American, born 1936
Star of Persia I. 1967. Lithograph, 22½ x 25¹⁵⁄₁₆" (57.1 x 65.9 cm). John B. Turner Fund.*
Star of Persia II. 1967. Lithograph, 22½ x 25¹⁵⁄₁₆" (57.1 x 65.9 cm). Gift of William A. Nitze.*
Irving Blum Memorial Edition. 1967. Lithograph, 22½ x 25¹⁵⁄₁₆" (57.1 x 65.9 cm). Acquired with matching funds from James R.

Epstein, Mrs. Gertrud A. Mellon, and the National Endowment for the Arts.*

Tàpies, Antoni. Spanish, born 1924
Impressions of Hands. (1969.) Etching and aquatint, 19⁹⁄₁₆ x 15½" (49.6 x 39.3 cm). Donald Karshan Fund.*

Tilson, Joe. British, born 1928
Is This Ché Guevara? 1969. Silkscreen and collage, 39⅞ x 23¹¹⁄₁₆" (101.3 x 60.2 cm). Donald Karshan Fund.*

Tinguely, Jean. Swiss, born 1925
Plate from the portfolio *La Vittoria.* (1972.) Offset, rubber stamp, felt pen, pencil, decal, cellophane tape, feather, 17⁵⁄₁₆ x 13⅛" (44.0 x 33.3 cm). Purchase.*

Tuttle, Richard. American, born 1941
Print. 1976. Silkscreen on two sheets, 5⁹⁄₁₆ x 11¹⁄₁₆" (14.1 x 28.1 cm). Junior Council Fund.*

Twombly, Cy. American, born 1929
Untitled II. 1967. Etching and aquatint, 23⅝ x 28¼" (60.0 x 71.7 cm). Gift of Celeste Bartos.*

Vasarely, Victor. French, born Hungary 1908
Two from the portfolio *Homage to the Hexagon.* (1969.) Silkscreen, each 23¾ x 23¹³⁄₁₆" (60.3 x 60.5 cm). Gift of Galerie Denise René.*

de la Villeglé, Jacques. French, born 1926
No. 1965. Silkscreen, 28⅛ x 23¹⁄₁₆" (71.5 x 58.6 cm). Lent by the Bibliothèque Nationale, Paris.

Visser, Carel. Dutch, born 1928
Untitled. 1965. Woodcut, 17¾ x 31½" (45.1 x 80.0 cm). Lent by the Stedelijk Museum, Amsterdam.

Vostell, Wolf. German, born 1932
Starfighter from the portfolio *Grafik des Kapitalistischen Realismus.* 1967. Silkscreen, 20⅞ x 32⅛" (53.0 x 81.5 cm). Lent by the Bibliothèque Nationale, Paris.

Warhol, Andy. American, born 1930
Marilyn Monroe Diptych. 1962. Silkscreen, enamel, and acrylic on canvas, 2 panels, each 82 x 57" (204.0 x 144.8 cm). Lent by the Collection of Mr. and Mrs. Burton Tremaine, Meriden, Connecticut.

Wesselmann, Tom. American, born 1931
Nude from the portfolio *11 Pop Artists,* Vol. II. (1965.) Silkscreen, 23¹⁵⁄₁₆ x 29⅝" (60.8 x 75.2 cm). Gift of Original Editions.*

BOOKS, POSTCARDS, AND BROADSIDES

With the exception of traditional illustrated books (livres de luxe), references to media and number of illustrations (plates) are omitted.

Acconci, Vito. American, born 1940
Behavior Fields: Notes on the Development of a Show. Hamburg: Edition Hossmann, 1973. 24 ff., 6 x 13″ (15.2 x 33.0 cm). Mrs. Alfred R. Stern Fund.*
Pulse (for my Mother)/(pour sa mère). Paris: Multiplicata and Sonnabend Gallery, 1973. 12 ff., 5¼ x 8¼″ (13.3 x 21.0 cm). Gift of Sonnabend Gallery.*
Think/Leap/Re-think/Fall. Dayton, Ohio: University Art Galleries, Wright State University, 1976. 28 ff., 8 x 8″ (20.3 x 20.3 cm). Gift of the publisher.*

Anderson, Laurie. American, born 1947
October 1972. New York: the artist, (1972). 31 ff., 8½ x 11″ (21.6 x 27.9 cm). Gift of John Gibson.*
Notebook. New York: The Collation Center, 1977. 24 ff., 5⅜ x 6¹⁵⁄₁₆″ (13.7 x 17.6 cm). Gift of the publisher and Wittenborn Art Books, Inc.*

Andre, Carl. American, born 1935
America Drill, One Hundred Sonnets, Three Operas from *Seven Books of Poetry.* New York: Dwan Gallery, Seth Siegelaub, 1969. 47 ff., 101 ff., 59 ff., 11 x 8½″ (27.9 x 21.6 cm). John B. Turner Fund.*

Anuszkiewicz, Richard. American, born 1930
Inward Eye by William Blake. Baltimore: Aquarius Press, 1970.
10 silkscreens, 25¾ x 19⅞″ (65.4 x 50.5 cm). Purchase.*

Attalai, Gabor. Hungarian, born 1934
Identifications. Budapest, September 26, 1972. 8 ff., 8³⁄₁₆ x 8⅝″ (20.8 x 21.9 cm).†

Baldessari, John. American, born 1931
Choosing: Green Beans. Milan: Edizioni Toselli, 1972. 13 ff., 11⅝ x 8³⁄₁₆″ (29.5 x 20.8 cm).†
Ingres and Other Parables. London: Studio International Publications, 1972. 12 ff., 10⅝ x 12¹⁄₁₆″ (27.0 x 30.6 cm).†

Barry, Robert. American, born 1931
Robert Barry. Cologne: Gerd de Vries with Paul Maenz, 1971. 35 ff., 11¾ x 8¼″ (29.9 x 21.0 cm).†
Two Pieces. vols. 1 and 2. Turin: Sperone Editore-Editarte, 1971. vol. 1: 45 ff.; vol. 2: 45 ff.; 6¾ x 4½″ (17.2 x 11.4 cm).†

Becher, Bernhard and Hilla. German, born 1931 and 1934
Anonyme Skulpturen: Eine Typologie technischer Bauten. Düsseldorf: Art-Press, 1970. 108 ff., 11 x 8½″ (27.9 x 21.6 cm).†

Ben (Vautier). Swiss, born Naples 1935
Moi, Ben je signe. Brussels: Lebeer Hossmann Editeurs, 1975. 29 ff., 12¼ x 8⅝″ (31.1 x 21.9 cm). Mrs. Alfred R. Stern Fund.*

Beuys, Joseph. German, born 1921
Friedrichsplatz. Heidelberg: Edition Tangente (Series 3: Kassel), 1968. Postcard, 4⅛ x 5¹³⁄₁₆″ (10.5 x 14.7 cm).*
la gebratene Fischgräte. Berlin: Edition Hundertmark, 1972. 106 pp., 7¼ x 9½″ (18.4 x 24.1 cm).†
Heidelberg. Heidelberg: Edition Tangente (Series 5: Heidelberg), n.d. Postcard, 4⅛ x 5¹³⁄₁₆″ (10.5 x 14.7 cm).*

Bochner, Mel. American, born 1940
Seven Translucent Tiers . . . from Aspen 5 + 6 for Stephane Mallarmé, Fall–Winter 1967. 7 ff., 8 x 8″ (20.3 x 20.3 cm).*
Misunderstandings (A Theory of Photography) from *Artists and Photographs.* New York: Multiples Inc., 1970. 10 ff., 6 x 9″ (15.2 x 22.9 cm).†
Primer. The Complete Catalogue of Twenty-One Demonstrations from a "Theory of Sculpture: (Counting)." Milan: Flash Art, 1973. 26 ff., 9¼ x 6½″ (23.5 x 16.5 cm).†

Boltanski, Christian. French, born 1944
Reconstitution de gestes effectués par Christian Boltanski entre 1948 et 1954. Paris: The artist, (1970). 8 ff., 8¼ x 5⅜″ (21.0 x 13.7 cm). Gift of Sonnabend Gallery.*
10 portraits photographiques de Christian Boltanski 1946–1964. Paris: Multiplicata and Sonnabend Press, 1972. 11 ff., 8¼ x 5⅜″ (21.0 x 13.7 cm). Gift of Sonnabend Gallery.*

Brecht, George. American, born 1940, lives in France. And

Filliou, Robert. French, born 1926
Games at the Cedilla, or the Cedilla Takes Off. New York: Something Else Press, 1967. 80 ff., 7¾ x 5¼″ (19.7 x 13.3 cm). Mrs. Alfred R. Stern Fund.*

Brehmer, K. P. German, born 1938
Museum Fridericanum. Heidelberg: Edition Tangente (Series 3: Kassel), 1968. Postcard, 4⅛ x 5¹³⁄₁₆″ (10.5 x 14.7 cm).*

Broodthaers, Marcel. Belgian, 1924–1976
Un coup de dés jamais n'abolira le hasard. Antwerp: Galerie Wide White Space; Cologne: Galerie Michael Werner; 1969. 15 ff., 12¾ x 9¾″ (32.4 x 24.7 cm). Mrs. Alfred R. Stern Fund.*
Der Adler vom Oligozän bis heute. vols. I and II. Düsseldorf: Städische Kunsthalle, 1972. vol. I: 64 pp.; vol. II: 64 pp.; 8¼ x 5¹³⁄₁₆″ (21.0 x 14.8 cm).†
Charles Baudelaire: Je hais le mouvement qui déplace les lignes. Hamburg: Edition Hossmann, 1973. 8 ff., 12¾ x 9¾″ (32.4 x 24.7 cm). Gift of the publisher.*

Fuchs/Mais qui mangera le fromage? Berlin, 1974. Postcard, 4⅛ x 5¹³/₁₆″ (10.5 x 14.8 cm).*

L'Angelus de Daumier, Parts 1 and 2. Paris: Centre National d'Art et de Culture Georges Pompidou, Musée National d'Art Moderne, 1975. Part 1: 16 ff.; Part 2: 16 ff.; 10 x 8¹/₁₆″ (25.4 x 20.5 cm).†

En lisant la Lorelei. Munich: Edition der Galerie Heiner Freidrich, 1975. 14 ff., 12⅝ x 9¾″ (32.0 x 24.7 cm). Carol O. Selle Fund.*

Brouwn, Stanley. Dutch, born Surinam 1935
This Way Brouwn 25-2-61/26-2-61. New York and Cologne: Gebr. König, 1971. 63 ff., 9⁷/₁₆ x 7¹³/₁₆″ (24.0 x 19.9 cm).†

100.000 mm. Brussels: Gallery MTL, 1975. 52 ff., 6⅛ x 6¼″ (15.6 x 15.9 cm).*

1 m 1 step. Eindhoven: Stedelijk van Abbemuseum, 1976. 8 ff., 39⅜ x 3¹⁵/₁₆″ (100.0 x 10.0 cm). Library.*

Buren, Daniel. French, born 1938
Limites critiques. Paris: Yvon Lambert, (1970). 6 ff., 10⅝ x 7¹/₁₆″ (27.0 x 17.9 cm). Mrs. Alfred R. Stern Fund.*

Passage. Macerata, Italy: Edizione Artestudia, 1972. 7 vols., 215 plates, 20⁹/₁₆ x 20⁹/₁₆″ (52.2 x 52.2 cm). Purchase.*

5 Texts. New York: The John Weber Gallery; London: The Jack Wendler Gallery; 1973. 64 pp., 9 x 6″ (22.9 x 15.2 cm).†

Reboundings. Brussels: Daled and Gavaert, 1977. 73 pp., 10 ff., 8 x 5⅛″ (20.3 x 13.0 cm). Purchase.*

Burgin, Victor. English, born 1941
Family. New York: Lapp Princess Press Ltd., 1977. 7 ff., 6 x 6″ (15.3 x 15.3 cm).*

Burgy, Donald. American, born 1937
Art Ideas for the Year 4000. Andover, Massachusetts: Addison Gallery of American Art, 1970. 18 ff., 9 x 8½″ (22.9 x 21.6 cm).†

Burn, Ian. Australian, born 1939
One Structure. New York: The artist, 1969. 104 ff., 8¼ x 10⅞″ (21.0 x 27.6 cm). Gift of Donald Karshan.*

Byars, James Lee. American, born 1932
Black Dress from *SMS,* February 1968, no. 1. Envelope and cutout, 10 x 10″ (25.4 x 25.4 cm). Gift of Carol O. Selle.*

Cage, John. American, born 1912
Writing through Finnegans Wake & Writing for the Second Time through Finnegans Wake. New York: Printed Editions, 1978. 90 ff., 11 x 9½″ (27.9 x 24.1 cm). Gloria Kirby Fund.*

Castillejo, José Luis. Spanish, born 1930
The Book of Eighteen Letters. Madrid: Artes Gráficas Luis Perez, 1972. 177 ff., 9½ x 6¾″ (24.1 x 17.2 cm).†

Cutforth, Roger. English, born 1944
CN/ET/ESB The Non-Art Project. New York: The artist, 1971. 10 ff., 5½ x 7½″ (14.0 x 19.1 cm). Gift of John Gibson.*

The Empire State Building. New York: The artist, 1971. 11 ff., 8½ x 5½″ (21.6 x 14.0 cm). Gift of John Gibson.*

Darboven, Hanne. German, born 1941
Information. Milan: Flash Art Edizioni, 1973. 36 ff., 8½ x 11½″ (21.6 x 29.2 cm).†

Diary NYC. February 15 until March 4, 1974. New York: Castelli Graphics; Turin: Gian Enzo Sperone; 1974. 135 ff., 9 x 12⅛″ (22.9 x 30.8 cm). Gift of the publishers.*

Denes, Agnes. American, born Hungary
Sculptures of the Mind. Akron, Ohio: Davis Art Gallery, University of Akron, 1976. 1 f., [1 p.], 48 pp., 11 x 8½″ (27.9 x 21.6 cm).*

Dimitrijević, Braco. Yugoslavian, born 1948
Self-Portraits after Rembrandt and Miguel Perez 1968–1978. Geneva: Centre d'Art Contemporain & Ecart Publications, 1978. 22 ff., 9⅜ x 6⅝″ (23.8 x 16.8 cm).*

Downsbrough, Peter. American, born 1940
Two Lines/Five Sections. London and New York: Jack Wendler, 1974. 44 ff., 6¼ x 4¼″ (15.9 x 10.8 cm). Gift of Jennifer Licht.*

Two Pipes/Fourteen Locations. New York: Norman Fisher, 1974. 38 ff., 7¾ x 4¾″ (19.7 x 12.1 cm). Gift of Jennifer Licht.*

As to Place. New York: The artist, 1978. 55 ff., 7 x 4½″ (17.8 x 11.4 cm). Gift of Jennifer Licht.*

Dubuffet, Jean. French, born 1901
Parade funèbre pour Charles Estienne. Paris: Editions Jeanne Bucher, 1967. 16 ff., 10¾ x 8⁹/₁₆″ (27.3 x 21.7 cm). Gift of Mr. and Mrs. Ralph F. Colin.*

Duchamp, Marcel. American, born France, 1887–1968
The Large Glass and Related Works (vol. II) by Arturo Schwarz. Milan: Schwarz Gallery, 1968. 9 etchings and aquatints, 16½ x 10″ (41.9 x 25.4 cm); with separate suite of the prints in two states, 9¹¹/₁₆ x 12⅞″ (50.0 x 32.7 cm). John B. Turner Fund.*

Feldmann, Hans-Peter. German, born 1941
3 Bilder. Hilden (Germany): The artist, 1970. 2 ff., 5½ x 3⅞″ (14.0 x 9.9 cm).*

14 Bilder. Hilden (Germany): The artist, 1971. 8 ff., 3¹⁵/₁₆ x 5¾″ (10.0 x 14.6 cm).*

1 Bild. Hilden (Germany): The artist, 1973. 2 ff., 8⅝ x 6″ (21.9 x 15.2 cm).*

Filliou, Robert. French, born 1926
Teaching and Learning as Performance Arts. With Joseph Beuys, George Brecht, John Cage, Dorothy Iannone, Allan Kaprow, Marcelle, Benjamin Patterson, Diter Rot, Vera and Bjössi and Karl Rot. New York and Cologne: Gebr. König, 1970. 229 pp. [1 p.], 8¼ x 11" (21.0 x 27.9 cm).†

Fulton, Hamish. English, born 1945
Hollow Lane. London: Situation Publications, (1971). 20 ff., 8¼ x 11¾" (21.0 x 29.8 cm).†
Nepal. Eindhoven: The Municipal van Abbemuseum, 1977. 10 ff., 8³⁄₁₆ x 11³⁄₁₆" (20.8 x 28.4 cm).*

Gilbert & George (Gilbert Proersch). English, born Austria 1943
(George Passmore). English, born 1942
Untitled. London: Art for All, n.d. (c. 1969). Broadside, 7⅞ x 6⅝" (20.0 x 16.8 cm).†
Towards Progress and Understanding in Art. London: Art for All, March–May, 1971. 7 folded cards with envelopes, 8 x 5" (20.3 x 12.7 cm).†
Side by Side. London: Nigel Greenwood; New York and Cologne: Gebr. König; 1972. 5 ff., [1 p.], 1–92 pp., 1 f., [1 p.], 93–132 pp., 1 f., [1 p.], 133–70 pp., 1 f., 7½ x 4¹⁵⁄₁₆" (19.1 x 12.6 cm).†
Dark Shadow. London: Nigel Greenwood, 1976. 141 ff., 7⁷⁄₁₆ x 4¾" (18.9 x 12.1 cm).†
Gilbert and George the Sculptors present Underneath the Arches. n.d. Broadside. 12⅛ x 9½" (30.8 x 24.1 cm).†

Graham, Dan. American, born 1942
Two Parallel Essays. New York: Multiples Inc., 1970. 8 pp., 11 x 7" (27.9 x 17.8 cm).†

Gudmundsson, Kristjan. Icelandic, born 1941
Circles. Amsterdam: Stedelijk Museum, 1973. 3 ff., 8³⁄₁₆ x 8³⁄₁₆" (20.8 x 20.8 cm).†

Haacke, Hans. German, born 1936
Seurat's "Les Poseuses" (small version), 1888–1975. n.p.: The artist, n.d. 15 ff., 11 x 8½" (27.9 x 21.6 cm).†

Hamilton, Richard. English, born 1922
A Postal Card for Mother from *SMS,* February 1968, no. 1. 5 x 8" (12.7 x 20.3 cm). Gift of Mrs. Carol O. Selle.*
München/Bordeaux: Friedensengel. Heidelberg: Edition Tangente (Series 4: München), 1971. Postcard, 4⅛ x 5¹³⁄₁₆" (10.5 x 14.7 cm).*

Harvey, Michael. English, born 1944
As Is. New York: The artist, (1972). 16 ff. (uncut), 6⅛ x 4½" (15.6 x 11.4 cm). Gift of the artist.*

Higgins, Richard C. American, born 1938
Jefferson's Birthday and *Postface.* New York:

Something Else Press, 1964. x pp., 1 f., 271 pp. and vi pp., 3 ff., 90 pp., 7¹⁵⁄₁₆ x 5³⁄₁₆" (20.2 x 13.2 cm). Mrs. Alfred R. Stern Fund.*
foew&ombwhnw. New York: Something Else Press, 1969. 320 pp., 7¾ x 5¼" (19.7 x 13.3 cm). Mrs. Alfred R. Stern Fund.*

Hockney, David. English, born 1937
Six Fairy Tales from the Brothers Grimm. London: Petersburg Press, 1970. 39 etchings and separate suite of 6 etchings, 17⁹⁄₁₆ x 12⅛" (44.6 x 30.8 cm). Monroe Wheeler Fund.*

Huebler, Douglas. American, born 1942
Duration. Turin: Sperone Editore, 1970. 59 ff., 6⅝ x 4½" (16.8 x 11.4 cm). Gift of the publisher.*

Johns, Jasper. American, born 1930
Foirades by Samuel Beckett. London and New York: Petersburg Press, 1976. 92 ff., 33 etchings and aquatints, 13¹⁄₁₆ x 9¹⁵⁄₁₆" (33.2 x 25.2 cm). Gift of Celeste and Armand Bartos.*

Johnson, Ray. American, born 1927
The Paper Snake. New York: Something Else Press, 1965. 25 ff., 8⁵⁄₁₆ x 10³⁄₁₆" (21.1 x 25.9 cm). Mrs. Alfred R. Stern Fund.*

Kaprow, Allan. American, born 1927
Some Recent Happenings. New York: A Great Bear Pamphlet, Something Else Press, 1966. 14 pp., 8½ x 5½" (21.6 x 14.0 cm). Mrs. Alfred R. Stern Fund.*

Katz, Alex. American, born 1927
The Face of the Poet. New York: Brooke Alexander and Marlborough Graphics, 1978. 14 aquatints, 14½ x 19" (36.8 x 48.3 cm). Acquired with matching funds from James R. Epstein and the National Endowment for the Arts.*

Klein, Yves. French, 1928–1962
Le dépassement de la problématique de l'art. La Louvière (Belgium): Editions de Montbliart, 1959. 1 f., 32 pp., 8½ x 6³⁄₁₆" (21.6 x 15.7 cm). Gift of Donald Karshan.*

Knowles, Alison. American, born 1933
by Alison Knowles. New York: A Great Bear Pamphlet, Something Else Press, 1965. 16 pp. (including covers), 8½ x 5½" (21.6 x 14.0 cm). Mrs. Alfred R. Stern Fund.*
from the publication a house of dust. Heidelberg: Edition Tangente (Series 1: Köln), n.d. Postcard, 4¹⁄₁₆ x 5¾" (10.3 x 14.6 cm).*

Kosuth, Joseph. American, born 1945
Function. Turin: Sperone Editore, 1970. 47 ff., 6½ x 4¼" (16.5 x 10.8 cm). Gift of the publisher.*

Le Gac, Jean. French, born 1936
Le décor. Paris: Multiplicata, 1972. 9 ff., 5¼ x 8¼" (13.4 x 21.0 cm). Purchase.*

Levine, Les. Canadian, born Ireland 1935

Catalogue of Services 1971. New York: Museum of Mott Art, Inc., 1971. [1 p.], 11 pp., 8⅜ x 5⁷⁄₁₆″ (21.3 x 13.8 cm). Gift of the artist.*
After Art. New York: Museum of Mott Art, Inc., 1974. 12 pp., 8⅜ x 5³⁄₁₆″ (21.3 x 13.2 cm).†

LeWitt, Sol. American, born 1928
Set II, 1–24. Los Angeles: Ace Gallery, 1968. [1 p.], 24 pp. 9⅞ x 10″ (25.1 x 25.4 cm).†
Four Basic Kinds of Straight Lines. London: Studio International, 1969. 16 ff., 7⅞ x 7⅞″ (20.0 x 20.0 cm).†
Arcs Circles & Grids. Bern: Kunsthalle, 1972. 104 ff., 8⅛ x 8″ (20.6 x 20.3 cm).†
Grids, using straight lines, not-straight lines & broken lines in all their possible combinations. New York: Parasol Press, 1973. 28 ff., 10⅝ x 10⅝″ (27.0 x 27.0 cm). Purchase.*
Arcs and Lines. Lausanne: Editions des Massons; Paris: Yvon Lambert; 1974. 28 ff., 8 x 8″ (20.3 x 20.3 cm). Mrs. Alfred R. Stern Fund.*
Drawing Series I, II, III, IIII a & b (1970). Turin: Galleria Sperone; Düsseldorf: Konrad Fisher; 1974. 112 ff., 8⅞ x 8⅞″ (22.5 x 22.5 cm). Gift of the artist.*
Geometric Figures & Color. New York: Abrams, 1979. 24 ff., 8 x 8″ (20.3 x 20.3 cm).*

Long, Richard. English, born 1945
Two sheepdogs cross in and out of the passing shadows The clouds drift over the hill with a storm. London: Lisson Publications, 1971. 6 ff. (including covers), 11 x 7¼″ (27.9 x 18.4 cm).†
The North Woods. London: Whitechapel Art Gallery, 1977. 8 ff., 8¼ x 11¾″ (21.0 x 29.8 cm).†
River Avon Book. n.p. (1979?). 32 ff., 5⅞ x 5⅛″ (15.0 x 13.0 cm).†

Marioni, Tom. American, born 1937
See What I'm Saying. N.p.: The artist, (1978). 7 pp., 10⅜ x 8⅛″ (26.3 x 20.7 cm).*

Matta-Clark, Gordon. American, 1945–1978
Walls paper. New York: Buffallo press, 1973. 72 ff. (horizontally divided in half), 10 x 7″ (25.4 x 17.8 cm). Gift of John Gibson.*
Splitting. New York: Loft Press, 1974. 16 ff. (with 1 fold-out), 7 x 11⅛″ (17.8 x 28.6 cm). Gift of John Gibson Gallery.*

Meneeley, Edward. American, born 1927
Illustrations for Tender Buttons (by Gertrude Stein). New York: Teuscher Editions, 1965. Xerox, 22 ff., 14 x 18½″ (35.6 x 47.0 cm). John B. Turner Fund.*

Merz, Mario. Italian, born 1925
Fibonacci 1202. Turin: Sperone Editore, 1970. 56 ff., 6⅜ x 3¾″ (16.2 x 9.5 cm).†
Tables from Drawings of Mario Merz.

New York: John Weber Gallery; London: Jack Wendler Gallery; 1974. 8 ff. (including covers), 8 x 10″ (20.3 x 25.4 cm).†

Messager, Annette. French, born 1943
Ma collection de proverbes: Annette Messager collectionneuse. Milan: Giancarlo Politi Editore, 1976. 55 ff., 4½ x 6½″ (11.4 x 16.5 cm). Mrs. Alfred R. Stern Fund.*

Motherwell, Robert. American, born 1915
A la Pintura by Rafael Alberti. West Islip: Universal Limited Art Editions, 1972. 21 etchings and aquatints, 25¾ x 38″ (65.4 x 96.5 cm). Gift of Celeste Bartos.*

Nauman, Bruce. American, born 1941
L A Air from *Artists and Photographs*. New York: Multiples Inc., 1970. 6 ff., 12 x 12″ (30.5 x 30.5 cm).†

Ontani, Luigi. Italian
Untitled. Turin: Galleria LP 220/Franz Paludetto Editore, n.d. 43 pp., [2 pp.], 6¼ x 4½″ (15.9 x 11.4 cm). Gift of Sonnabend Gallery.*

Opalka, Roman. Polish, born France 1931
Opalka 1965/1-00-Travel Sheets. Turin: Galleria LP 220, 1972. 14 ff., 9 x 5¾″ (22.9 x 14.6 cm).†

Oppenheim, Dennis. American, born 1938
Flower Arrangement for Bruce Nauman from *Artists and Photographs*. New York: Multiples Inc., 1970. 1 f. (folded), 6⅝ x 9½″ (16.8 x 24.1 cm).†

Panamerenko. Belgian, born 1940
The Mechanism of Gravity, Closed Systems of Speed Alteration; Insect Flight Seen from Inside the Body of the Insect; The Helicopter as a Potential Winner; "U-Kontrol III," An Improved Airplane Driven by Human Power; "Polistes," Rubber Car with Jet Propulsion; "Scotch-Gambit," The Design of a Large Fast Flying Boat. Bielefeld (Germany): Edition Marzona, 1975. 144 pp., 8⁵⁄₁₆ x 6⅛″ (21.1 x 15.6 cm). Mrs. Alfred R. Stern Fund.*

Penck, A. R. (Ralf Winkler). East German, born 1939
Standart Making. Cologne: Galerie Michael Werner, 1970. 150 ff., 11¹¹⁄₁₆ x 8¼″ (29.7 x 21.0 cm). Mrs. Alfred R. Stern Fund.*
Was ist Standart. New York and Cologne: Gebr. König, 1970. 88 ff., 8¼ x 5½″ (21.0 x 14.0 cm). Mrs. Alfred R. Stern Fund.*

Penone, Giuseppe. Italian, born 1947
Svolgere la propria pelle. Turin: Sperone Editore, 1971. 53 ff., 8⁹⁄₁₆ x 8⁵⁄₁₆″ (21.8 x 21.1 cm). Gift of the publisher.*

Pistoletto, Michelangelo. Italian, born 1933
Untitled (Cento mostre nel mese di ottobre).

Turin: Giorgio Persano, 1976. [6 ff.], 100 ff., [1 f.], 3⅝ x 3½" (9.2 x 8.9 cm).*
Poirier, Anna and Patrick. French, born 1942. French, born 1942
Les De/Réalités Incompatibles. Copenhagen: H. M. Bergs Forlag ApS., 1975. 30 ff., 8½ x 6½" (21.6 x 16.5 cm).†
Reuterswärd, Carl Fredrik. Swedish, born 1934
Prix Nobel. Stockholm: Tryckeri AB Björkmans Eftr., 1966. 96 pp., 6¾ x 4¾" (17.2 x 12.1 cm).†
Roth, Dieter (Dietrich Roth). Swiss, born Germany 1930
Bok. Reykjavik: Forlag Ed., (1959). 40 ff. (with 2 fold-outs). 8⅝ x 9" (21.9 x 22.9 cm). Library.*
246 Little Clouds. New York: Something Else Press, 1968. 88 ff., 9 x 5⅞" (22.9 x 14.9 cm). Mrs. Alfred R. Stern Fund.*
Rathaus. Heidelberg: Edition Staeck (Series 3: Kassel), 1968. Postcard, 4 x 5¹¹⁄₁₆" (10.2 x 14.4 cm).*
Ruppersberg, Allen. American, born 1944
Greetings from L.A. Los Angeles: The artist, (1972). 240 pp., 8 x 5¼" (20.3 x 13.3 cm).†
Ruscha, Edward. American, born 1937
Twenty-six Gasoline Stations. 1962. (Hollywood: National Excelsior Publication, 1963.) 24 ff., 7⅛ x 5⁹⁄₁₆" (18.1 x 14.2 cm).†
Thirty-four Parking Lots. Los Angeles: The artist, 1967. 22 ff., 10 x 8" (25.4 x 20.3 cm).†
Babycakes with Weights from *Artists and Photographs.* New York: Multiples Inc., 1970. 24 ff., 7½ x 6" (19.1 x 15.2 cm).†
Various Small Fires and Milk. Los Angeles: Anderson Ritchie & Simon, 1964. 18 ff., 7 x 5½" (17.8 x 14.0 cm).†
The Sunset Strip. Los Angeles: The artist, 1966. 1 f. (folded), 6¹⁵⁄₁₆ x 5½" (17.6 x 14.0 cm).†
Colored People. Hollywood: Heavy Industry Publications, 1972. 16 ff., 7¹⁄₁₆ x 5½" (17.9 x 14.0 cm).†
Sandback, Fred. American, born 1943
16 Variations on 2 Diagonal Lines. 1972. Munich: Galerie Heiner Friedrich and Erik A. Mosel Verlag, 1973. 17 ff., 8¹⁄₁₆ x 8" (20.5 x 20.3 cm). Given anonymously.*
16 Variations on 2 Horizontal Lines. 1973. Munich: Galerie Heiner Friedrich and Erik A. Mosel Verlag, 1973. 17 ff., 8¹⁄₁₆ x 8" (20.5 x 20.3 cm). Given anonymously.*
Snow, Michael. Canadian, born 1928
Cover to Cover. New York: New York University Press; Halifax: Nova Scotia College of Art and Design; 1975. 158 ff., 8⅞ x 7" (22.6 x 17.8 cm). Library.*

Spagnulo, Giuseppe. Italian, born 1936
Archeologia. Munich: Ottenhausen Verlag, 1978. 16 ff. (including covers), 8¹¹⁄₁₆ x 8⅝" (22.1 x 21.9 cm). Purchase.*
Stokes, Telfer. English, born 1940
Passage. N.p.: Weproductions, April 8, 1972. 64 ff., 7 x 4¼" (17.8 x 10.8 cm).†
Foolscrap. London: Weproductions, 1973. 80 ff., 7 x 4¼" (17.8 x 10.8 cm).†
Spaces. London: Weproductions, 1974. 80 ff., 7 x 4¼" (17.8 x 10.8 cm).†
Titus-Carmel, Gérard. French, born 1942
Sarx by Pascal Quignard. Paris: Maeght, 1977. 12 drypoints and aquatints, 9½ x 7" (24.1 x 17.8 cm). Mrs. Alfred R. Stern Fund.*
Tuttle, Richard. American, born 1941
Two Books. Cologne: Galerie Rudolf Zwirner; New York: Betty Parsons Gallery; (1969). vol. 1: 10 ff.; vol. 2: 31 ff.; 12 x 9⅝" (30.5 x 24.5 cm) and 12 x 9⅛" (30.5 x 23.2 cm). Monroe Wheeler Fund.*
Venet, Bernar. French, born 1941
Mathématique: Computation of Tangent, Euler, and Bernoulli Numbers; Astrophysique: A Discussion of the URSA Minor Dwarf Galaxy Based on Plates Obtained by Walter Baade; Texte Analytique: Bernar Venet: Logique du Neutre (par Thierry Kuntzel). Paris: Arthur Hubschmid, 1975. 38 ff. (1 fold-out), 11⅜ x 8" (28.9 x 20.3 cm). Mrs. Alfred R. Stern Fund.*
Vostell, Wolf. German, born 1932
Multimedia Environment. Heidelberg: Edition Tangente (Series 3: Kassel), 1968. Postcard, 4⅛ x 5¹³⁄₁₆" (10.5 x 14.7 cm).*
Warhol, Andy. American, born 1930
Andy Warhol's Index (Book). New York: A Black Star Book/Random House, 1967. 32 ff. (3 fold-outs), 11 x 8⅜" (27.9 x 21.3 cm).†
Flash by Phillip Greer. Briarcliff Manor: Racolin Press, 1968. 11 silkscreens, 21⁷⁄₁₆ x 21¼" (54.3 x 54.0 cm). Gift of Philip Johnson.*
Weiner, Lawrence. American, born 1940
Statements. New York: Seth Siegelaub, 1968. 29 ff., 7 x 4" (17.8 x 10.2 cm). Gift of The International Program.*
Causality Affected and/or Effected. New York: Leo Castelli, 1971. 37 ff., 6½ x 4¼" (16.5 x 10.8 cm).†
Various Manners with Various Things. London: Institute of Contemporary Art, 1976. 31 ff., 6 x 4¾" (15.3 x 12.1 cm).†
Wewerka, Stefan. German, born 1928
For Our Little Darlings (Frühlinksanfank). Stuttgart: Edition Hansjörg Mayer, 1969. 6 ff.,

8¾ x 8⁵⁄₁₆″ (22.2 x 21.1 cm). Mrs. Alfred R. Stern Fund.*

Williams, Emmett. American, born 1925

13 Variations. Cologne: Edition MAT MOT, 1965. Rubber stamp, 1 fold-out sheet, 8⅞ x 8⅞″ (22.6 x 22.6 cm). Gift of Carol O. Selle.*

The Voyage. Stuttgart: Edition Hansjörg Mayer, 1975. 130 ff., 6¹¹⁄₁₆ x 6¹¹⁄₁₆″ (17.0 x 17.0 cm).*

MISCELLANEOUS ARTISTS

An Anthology by George Brecht, Claus Bremer, Earle Brown, Joseph Byrd, John Cage, David Degener, Walter De Maria, Terry Jennings Dennis, Ding Dong, Henry Flynt, Simone Forti, Dick Higgins, Toshi Ichiyanagi, Ray Johnson, Jackson MacLow, Richard Maxfield, Yoko Ono, Nam June Paik, Terry Riley, Dieter Rot, Malka Safro, James Waring, Emmett Williams, Christian Wolff, La Monte Young. New York: Heiner Friedrich, 2nd edition 1970. 56 ff. (2 inserts), 8⅛ x 8¹⁵⁄₁₆″ (20.7 x 22.7 cm). Gift of the publisher.*

Art-Language, vol. 1, nos. 1 and 2, vol. 3, no. 3. May 1969, February 1970, June 1976. 8¼ x 5⅞″ (21.0 x 14.9 cm).†

The Desert is Across the Street by Urs Lüthi, Elke Kilga, David Weiss. Amsterdam: Edition de Appel; and Zürich: Galerie Stähli; 1975. 16 ff., 8⁵⁄₁₆ x 11¹¹⁄₁₆″ (21.1 x 29.7 cm).*

Manifestos by Ay-O, Philip Corner, W.E.B. DuBois Clubs, Oyvind Fahlström, Robert Filliou, John Giorno, Al Hansen, Dick Higgins, Allan Kaprow, Alison Knowles, Nam June Paik, Diter Rot, Jerome Rothenberg, Wolf Vostell, Robert Watts, Emmett Williams. New York: A Great Bear Pamphlet, Something Else Press, 1966. 31 pp., 8⅝ x 5½″ (21.9 x 14.0 cm). Mrs. Alfred R. Stern Fund.*

One Month, Seth Siegelaub, ed. New York: Seth Siegelaub, 1969. 33 ff., 7 x 8½″ (17.8 x 21.6 cm).†

Stamped Indelibly by Red Grooms, Robert Indiana, Allen Jones, Marisol, Claes Oldenburg, Peter Saul, Andy Warhol, Tom Wesselmann. New York: Indianakatz, 1967. 15 rubber stamps, 11³⁄₁₆ x 8⅜″ (28.4 x 21.3 cm). John B. Turner Fund.*

Untitled (Xerox Book) by Carl Andre, Robert Barry, Douglas Huebler, Joseph Kosuth, Sol LeWitt, Robert Morris, Lawrence Weiner. New York: Seth Siegelaub and John W. Wendler, 1968. 183 ff., 10¾ x 8¼″ (27.3 x 21.0 cm). Gift of Mrs. Ruth Vollmer.*

BIBLIOGRAPHY

The following is a selected bibliography. For additional references to printed art of this period, and to individual artists, see the bibliography in Castleman, Riva. *Prints of the Twentieth Century: A History*. New York: Museum of Modern Art, 1976.

GENERAL

Austin, Texas, University Art Museum. *German Graphics of the Sixties*. Exhibition catalog. Austin, 1974.

Berlin, Neuen Berliner Kunstvereins. *Grafische Techniken*. Exhibition catalog. Berlin, 1973.

Bloch, E. Maurice. *Words and Images: Universal Limited Art Editions*. Exhibition catalog. Los Angeles: UCLA Art Council, 1978.

Block, René. *Grafik des Kapitalistischen Realismus*. Berlin: Edition René Block, 1971.

Calas, Nicolas and Elena. *Icons and Images of the Sixties*. New York: E. P. Dutton, 1971.

Celant, Germano. *Art Povera*. New York: Praeger, 1969.

Celant, Germano. *Book as Artwork, 1960/72*. London: Nigel Greenwood, 1972.

Celant, Germano. *Precronistoria 1966–69*. Florence: Centro Di, 1976.

Chicago, Art Institute of Chicago. *Europe in the Seventies: Aspects of Recent Art*. Exhibition catalog. Chicago, 1977.

Clair, Jean. *Art en France: Une Nouvelle Génération*. Paris: Éditions du Chêne, 1972.

Field, Richard S. *Recent American Etching*. Exhibition catalog. Washington: National Collection of Fine Arts, Smithsonian Institution, 1975.

Field, Richard S. *Silkscreen: History of a Medium*. Exhibition catalog. Philadelphia: Philadelphia Museum of Art, 1971.

Finch, Christopher. *Pop Art: Object and Image*. London: Studio Vista/Dutton, 1968.

Geneva, Musée d'Art et d'Histoire. *Timbres et Tampons d'Artistes*. Exhibition catalog. Geneva, 1976.

Gilmour, Pat. *The Mechanized Image*. Exhibition catalog. London: Arts Council of Great Britain, 1978.

Graz, Neue Galerie am Landesmuseum Joanneum. *Van Arakawa bis Warhol: Grafik aus den USA*. Exhibition catalog. Graz (Austria), 1978.

Honisch, Dieter, and Jensen, Jens Christian, eds. *Amerikanische Kunst von 1945 bis Heute*. Cologne: Dumont Buchverlag, 1976.

Hunter, Sam, and Jacobus, John. *American Art of the 20th Century*. New York: Abrams, 1973.

Kultermann, Udo. *The New Painting*. Boulder (Colorado): Westview Press, 1977.

Lippard, Lucy R. *Six Years: The Dematerialization of the Art Object from 1966 to 1972*. New York: Praeger, 1973.

London, Arts Council of Great Britain. *3 → 8: New Multiple Art*. Exhibition catalog. London, 1970.

McWillie, Judith. "Exploring Electrostatic Print Media." *Print Review 7* (New York: Pratt Graphics Center), 1977, pp. 75–81.

Nuremberg, Kunsthalle. *Graphik der Welt*. Exhibition catalog. St. Gallen (Switzerland): Erker-Verlag, 1971.

Paris, Bibliothèque Nationale. *L'Estampe Aujourd'hui, 1973–1978*. Exhibition catalog. Paris, 1978.

Paris, Bibliothèque Nationale. *L'Estampe Contemporaine à la Bibliothèque Nationale*. Exhibition catalog. Paris, 1973.

Russell, John, and Gablik, Suzi. *Pop Art Redefined*. New York: Praeger, 1969.

Stuttgart, Staatsgalerie. *Amerikanische und Englische Graphik der Gegenwart*. Stuttgart, 1974.

Tousley, Nancy. *Prints: Bochner, LeWitt, Mangold, Marden, Martin, Renouf, Rockburne, Ryman*. Exhibition catalog. Toronto: Art Gallery of Ontario, 1975.

Wember, Paul. *Blattkünste Internationale Druckgraphik seit 1945*. Exhibition catalog. Krefeld (Germany): Kaiser Wilhelm Museum and Scherpe Verlag, 1973.

ARTISTS

Arakawa
 Arakawa, Shusaku, and Gins, Madeline H. *The Mechanism of Meaning*. New York: Abrams, 1979.

Asse, Geneviève
 Mason, Rainer Michael. *Geneviève Asse,*

L'Oeuvre Gravé: Catalogue Raisonné.
Exhibition catalog. Geneva: Musée d'Art et
d'Histoire, 1977.
Beuys, Joseph
Joseph Beuys: Multiples I and II. Munich:
Edition Jörg Schellmann, 1972 and 1974.
Broodthaers, Marcel
Marcel Broodthaers: Editionen (1964–1975).
Munich: Galerie Heiner Friedrich, 1978.
Buren, Daniel
Buren, Daniel. *5 Texts.* New York: The John
Weber Gallery; London: The Jack Wendler
Gallery; 1973.
Bury, Pol
Hannover, Kestner-Gesellschaft. *Pol Bury.*
Exhibition catalog. Hannover, 1971.
Canogar, Rafael
Parma, Università. Istituto di Storia dell'Arte.
Rafael Canogar. Parma, 1971.
Caulfield, Patrick
Finch, Christopher. *Patrick Caulfield.*
Baltimore: Penguin Books, 1971.
Christo (Christo Javacheff)
Bourdon, David. *Christo.* New York: Abrams,
1971.
Dine, Jim
Krens, Thomas, ed. *Jim Dine Prints: 1970–1977.*
New York: Harper & Row in association with
the Williams College Artist-in-Residence
Program, 1977.
Duchamp, Marcel
D'Harnoncourt, Anne, and McShine, Kynaston,
eds. *Marcel Duchamp.* Exhibition catalog.
New York: Museum of Modern Art;
Philadelphia: Philadelphia Museum of Art;
1973.
Schwarz, Arturo. *The Complete Works of
Marcel Duchamp.* New York:
Abrams, 1970.
Frankenthaler, Helen
Jacksonville, Jacksonville Art Museum. *Helen
Frankenthaler.* Exhibition catalog.
Jacksonville (Florida), 1977.
Hamilton, Richard
Morphet, Richard. *Richard Hamilton.*
Exhibition catalog. London: Tate Gallery,
1970.
Hockney, David
David Hockney by David Hockney. New York:
Abrams, 1976.
Indiana, Robert
Katz, William. *Robert Indiana: The Prints and
Posters, 1961–1971.* Stuttgart and New York:
Edition Domberger, 1971.

Iseli, Rolf
Geneva, Musée d'Art et d'Histoire. *Rolf Iseli:
Oeuvre Gravé.* Geneva, 1975.
Zürich, Kunsthaus. *Rolf Iseli.* Exhibition
catalog. Zürich, 1978.
Johns, Jasper
Field, Richard S. *Jasper Johns: Prints, 1970–1977.*
Exhibition catalog. Middletown (Connecticut):
Wesleyan University, 1978.
Field, Richard S. *Jasper Johns/Screenprints.*
Exhibition catalog. New York: Brooke
Alexander, 1977.
Geelhaar, Christian. *Jasper Johns: Working
Proofs.* Exhibition catalog. Basel:
Kunstmuseum, 1979.
Rose, Barbara. *Jasper Johns: 6 Lithographs
(after 'Untitled 1975'), 1976.* Los Angeles:
Gemini G.E.L., 1977.
Katz, Alex
Solomon, Elke, and Field, Richard. *Alex Katz:
Prints.* Exhibition catalog. New York:
Whitney Museum of American Art, 1974.
Kosuth, Joseph
Lucerne, Kunstmuseum. *Joseph Kosuth:
Investigationen uber Kunst & 'Problemkreise'
seit 1965.* Exhibition catalog. Lucerne, 1973.
Kounellis, Jannis
"Jannis Kounellis," Interview by Robin White.
View, vol. I, no. 10 (Oakland: Point
Publications), 1979.
LeWitt, Sol
Basel, Kunsthalle, and Bern, Verlag Kornfeld
und Cie. *Sol LeWitt: Graphik 1970–1975.*
Exhibition catalog. Basel and Bern, (1975).
Luginbühl, Bernhard
Berlin, Nationalgalerie. *Bernhard Luginbühl:
Plastiken.* Exhibition catalog. Berlin, 1972.
Geneva, Musée d'Art et d'Histoire. *Bernhard
Luginbühl: Oeuvre Gravé.* Geneva, 1971.
Mack, Heinz
Düsseldorf, Stadtische Kunsthalle. *Mack:
Objeckte, Aktionen, Projekte.* Exhibition
catalog. Düsseldorf, 1972.
Mackazin: The Years 1957–67. Huppertzhof
(Germany): Published by Mack for Mack,
1967.
Michaux, Henri
Hannover, Kestner-Gesellschaft. *Henri Michaux.*
Exhibition catalog. Hannover, 1972.
Saint-Paul de Vence, Fondation Maeght. *Henri
Michaux: Peintures.* Exhibition catalog.
Saint-Paul de Vence, 1976.
Miró, Joan
Madrid, Salas de la Dirección General del

Patrimonio Artístico, Archives y Museos. *Joan Miró: Obra Gráfica*. Exhibition catalog. Madrid, 1978.

Paris, Musée d'Art Moderne de la Ville de Paris. *Miró: L'Oeuvre Graphique*. Paris, 1974.

Morellet, François
Eindhoven, Stedelijk van Abbemuseum. *François Morellet*. Exhibition catalog. Eindhoven (The Netherlands), 1971.

Motherwell, Robert
Robert Motherwell: Selected Prints, 1961–1974. New York: Brooke Alexander, 1974.

Nauman, Bruce
Los Angeles, County Museum of Art, and New York, Whitney Museum of American Art. *Bruce Nauman*. Los Angeles, 1972.

Newman, Barnett
Rosenberg, Harold. *Barnett Newman*. New York: Abrams, 1978.

Oldenburg, Claes
Baro, Gene. *Claes Oldenburg: Drawings and Prints*. London and New York: Chelsea House, 1969.
Stockholm, Moderna Museet. *Claes Oldenburg: Drawings, Watercolors, and Prints*. Stockholm, 1977.

Palermo, Blinky
Leverkusen, Städtisches Museum. *Palermo: Druckgraphik 1970–1974*. Exhibition catalog. Leverkusen (Germany), 1975.

Paolozzi, Eduardo
Miles, Rosemary. *The Complete Prints of Eduardo Paolozzi*. Exhibition catalog. London: Victoria and Albert Museum, 1977.

Pearlstein, Philip
Drüchers, Alexander. *Philip Pearlstein: Drawings and Prints 1946–1972*. Berlin: Staatliche Museum, 1973.

Penck, A. R.
Basel, Kunstmuseum. *A. R. Penck: Zeichnungen bis 1975*. Exhibition catalog. Basel, 1978.
Bern, Kunsthalle. *A. R. Penck*. Exhibition catalog. Bern, 1975.

Picasso, Pablo
Chicago, The Art Institute, and Paris, Galerie Louise Leiris. *Picasso: 347 Engravings, 16/3/68–5/10/68*. Exhibition catalog. Chicago, 1968.
Rau, Bernd. *Pablo Picasso: Das Graphische Werk*. Exhibition catalog. Stuttgart: Verlag Gerd Hatje, 1974.

Polke, Sigmar
Tübingen, Kunsthalle. *Sigmar Polke: Bilder, Tücher, Objekte*. Exhibition catalog. Tübingen (Germany), 1976.

Richter, Gerhard
Venice, 36th Venice Biennale, German Pavilion. *Gerhard Richter*. Exhibition catalog. Essen (Germany): Museum Folkwang, 1972.

Rauschenberg, Robert
Washington, National Collection of Fine Arts, Smithsonian Institution. *Robert Rauschenberg*. Exhibition catalog. Washington, 1976.

Rosenquist, James
Sarasota, John and Mable Ringling Museum of Art. *James Rosenquist Graphics Retrospective*. Exhibition catalog. Sarasota (Florida), 1979.

Roth, Dieter
Rot, Dieter. *Collected Works. Volume 20: Books and Graphics (Part 1) from 1947 until 1971*. Stuttgart: Edition Hansjörg Mayer, 1972.

Ruscha, Edward
Auckland, Auckland City Art Gallery. *Graphic Works by Edward Ruscha*. Auckland, 1978.
Minneapolis, The Minneapolis Institute of Arts. *Edward Ruscha, Young Artist*. A book accompanying the exhibition of prints, drawings, and books of Edward Ruscha. Minneapolis, 1972.

Snow, Michael
Venice, 35th Venice Biennale, Canadian Pavilion. *Michael Snow*. Exhibition catalog. Ottawa: National Gallery of Canada, 1970.

Sovák, Pravoslav
Cologne, Kölnischer Kunstverein. *Sovák: Radierung*. Exhibition catalog. Cologne, 1974.

Stella, Frank
Leider, Philip. *Frank Stella: Star of Persia I & II*. Los Angeles: Gemini G.E.L., 1967.

Tàpies, Antoni
Galfetti, Mariuccia, and Vogel, Carl. *Tàpies: Obra Gráfica 1947–1972*. Barcelona: Editorial Gustavo Gili, 1973.

Tilson, Joe
Parma, Istituto di Storia dell'Arte, Università di Parma. *Joe Tilson*. Exhibition catalog. Parma, 1974.

Tinguely, Jean
Geneva, Musée d'Art et d'Histoire. *Jean Tinguely: Dessins et Gravures pour les Sculptures*. Exhibition catalog. Geneva, 1976.

Titus-Carmel, Gérard
Paris, Centre National d'Art et de Culture Georges Pompidou. *Gérard Titus-Carmel: The Pocket-Size Tlingit Coffin*. Paris, 1978.

Visser, Carel
 Locher, J. *Carel Visser: Beelden–Tekeningen–Grafiek.* Vlaardingen (The Netherlands): Drukkerij van Dooren B.V., 1972.
Vostell, Wolf
 Wolf Vostell. Berlin: Galerie René Block, 1969.
Warhol, Andy
 Coplans, John. *Andy Warhol.* Greenwich (Connecticut): New York Graphic Society, 1970.

PHOTOGRAPH CREDITS